IMAGES
of America

SEATTLE RADIO

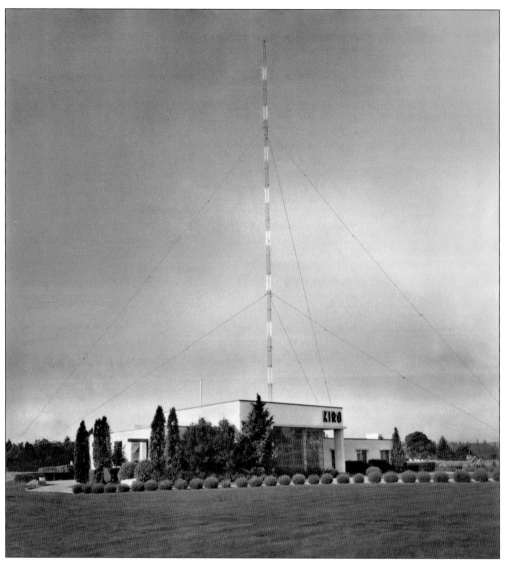

In 1941, KIRO became the first full-power 50,000-watt radio station west of Salt Lake City and north of San Francisco. Owner Saul Haas and chief engineer James B. Hatfield built this world-class transmitter facility on Maury Island. It was considered to be of national strategic importance during the war and was guarded by National Guard troops 24 hours a day. It was also the first directional antenna system built in the Northwest. Only one of KIRO's two towers is seen in this image. (Courtesy of Hatfield and Dawson.)

ON THE COVER: In 1948, KOMO opened Seattle radio's most elaborate studio facility. Located at the corner of Fourth Avenue and Denny Way, it served as the source of KOMO's radio and television broadcasts for 40 years. This was the KOMO master control room when the building first opened. The audio from all studios came here, along with the NBC network and remote broadcast lines. The operator at this desk controlled everything that was heard on the air. (Courtesy of Jack Barnes.)

IMAGES
of America

SEATTLE RADIO

John F. Schneider

ARCADIA
PUBLISHING

Published by Arcadia Publishing
Charleston, South Carolina

Printed in the United States of America

Library of Congress Control Number: 2013935137

For all general information, please contact Arcadia Publishing:
Telephone 843-853-2070
Fax 843-853-0044
E-mail sales@arcadiapublishing.com
For customer service and orders:
Toll-Free 1-888-313-2665

Visit us on the Internet at www.arcadiapublishing.com

This book is dedicated to the Seattle Chapter No. 16 of the Society of Broadcast Engineers and the SBE members who supported me during its creation. I was honored to be the Seattle SBE chapter chairman from 1991 to 1993.

CONTENTS

ACKNOWLEDGMENTS

As with any historical study, a lot of people contributed to this book. No one person has all of the information. The writer simply finds the people with the information and photographs and assembles it into a coherent story.

My involvement with the Seattle radio community was indirect. For 25 years, I ran a Seattle-area broadcast equipment sales business and dealt with most of the stations to support their technical needs. So, I observed Seattle radio from the sidelines, as a radio listener and as a friend of some participants, but I was not an expert on the subject. To prepare this book, I called on the support of many old friends and, in the process, made new friends. I also drew on information and photographs that I obtained decades ago from some of Seattle's earliest broadcasters, most of whom are now manning the big radio towers in the sky.

This story of Seattle radio is incomplete. There is not enough space to tell the stories of the thousands of important people and events that passed in front of the Puget Sound microphones during almost 90 years. Additionally, being a photograph essay, the story must be told through images. Some important events were not photographed, and the images of many others have not survived the years. If you, a family member, or a favorite radio personality are not mentioned in this book, please accept my apologies. For further reading, find a copy of David Richardson's classic 1981 book *Puget Sounds*.

It is essential to recognize the many people and organizations that assisted me in telling this story, including Carol Arkell, Jack Barnes, Sonny Clutter, Dick Curtis, Ben Dawson, Chris Dubuque, Ron Edge, Clay Freinwald, Frosty Fowler, Jim French, Jim Hatfield, Kim Hunter, Ivar's Restaurants, Walt Jamison, Nick Kerry, Howard Kraft, Christopher and Sandy Mael, Carolyn Marr (Museum of History & Industry), Gina Nelson, John Price, Homer Pope, Tom Read, Earl Reilly, Maia Santella, Andy Scotdal, Dwight Small, Bernice and Alex Smith, Bill Taylor, and George Walford.

I must also thank Alyssa Jones and the other professionals at Arcadia Publishing for their guidance in the creation of this work and for making it possible to bring you the story of Seattle radio.

—John F. Schneider
May 2013
www.theradiohistorian.org

INTRODUCTION

Although experimental radio telephone transmissions in Seattle—led by Lee de Forest, William Dubilier, and others—took place as early as 1906, the consumer radio boom did not hit Seattle until the fall of 1921. By 1922, radio was all the rage.

Seattle's first broadcaster was undoubtedly Vincent Kraft. He started broadcasting from the garage of his Ravenna home over his amateur station, 7XC, in 1919. He played phonograph and piano music through his 10-watt transmitter and single microphone. Other hams and early experimenters encouraged him to do more, and by March 1922, 7XC had been relicensed as KJR.

The city's second broadcaster was the *Seattle Post-Intelligencer*'s station KFC, transmitting from the roof of the P-I building at Sixth and Pine Streets. Carl Haymond was the program manager, announcer, engineer, and probably also the janitor. He led performers up the steep iron stairs to the roof and held a megaphone in front of the microphone while they sang or spoke into it.

Louis Wasmer started Seattle's third station, KHQ, from his motorcycle shop on Thirteenth Avenue N. After increasing power, he sold his old transmitter to the Economy Market, where it went on the air as KZC. Rhodes Brothers Department Store put KDZE on the air in May 1922, and Seattle City Light's John D. Ross put KTW on the air for the First Presbyterian Church.

In the first two years, all of these stations, plus some latecomers, were required to share time on a single frequency—360 meters (833 kilohertz)—and listeners could only hear one station at a time. A station would broadcast for an hour and then shut down to be replaced by another station, stronger or weaker than the last one. The stations met with the local radio inspector periodically to work out an operating schedule.

Many of these early stations had poor audio quality and suffered continuous technical difficulties, and people soon tired of listening to scratchy broadcasts of phonograph records, so in 1924 the government established a second class of station. Class B stations operated with at least 500 watts and were prohibited from playing phonograph records. They were assigned their own exclusive frequencies and could operate more hours each day. The remaining stations continued to share 360 meters. The Rhodes station—by now known as KFOA—was Seattle's first Class B station, assigned to the 660-kilohertz frequency. KJR and KTW later upgraded to Class B status as well.

As the decade progressed, many more stations were licensed, creating a glut. With just one channel available for most, there was no room for all to exist simultaneously. Many of these new stations were not serious efforts, only started by companies or individuals wanting to cash in on the radio boom. Many left the air within a year.

Roy Olmstead, Seattle's biggest bootlegger, started KFQX from his Mount Baker home in 1924. That November, federal prohibition agents raided the home, shut down the radio station, and arrested Olmstead, who was convicted and sent to McNeil Island Federal Penitentiary. KFQX was then leased to Birt Fisher, who ran it as KTCL, but in 1926 Olmstead sold it to KJR's Vincent Kraft, who planned to take over the station when the lease expired in December. So, Fisher joined forces with the owners of the Fisher Flouring Mills Co. to open a new station, KOMO.

Generously financed with a staff of 65 producing 14 hours of live programs a day, KOMO quickly became one of Seattle's most popular stations; meanwhile, Vincent Kraft took over KTCL and turned it into KXA.

Kraft's primary station, KJR, had grown into Seattle's other big radio operation by the late 1920s. Kraft built additional stations in Spokane, Portland, and San Francisco and tied them together in 1926 to create one of the first radio networks. In 1928, he sold his four stations to Adolph F. Linden and Edmund Campbell, directors of Puget Sound Savings & Loan. Soon, the money flowed freely, and KJR became among the most popular and best-financed stations in the Northwest. It had a large program staff with announcers, singers, a dance band, and a symphony orchestra. Linden expanded Kraft's network and formed the American Broadcasting Company (unrelated to today's ABC) to distribute his own shows and Columbia's (CBS) East Coast programs across the Western United States.

It was soon discovered where all of KJR's money was coming from. Linden and Campbell had been surreptitiously borrowing from their savings and loan association to run the station and finance their Camlin Hotel. When the savings and loan filed for bankruptcy in August 1929, the money stopped abruptly. Network phone lines were shut down for nonpayment, and most of KJR's staff and musicians departed when their paychecks stopped coming in. Linden and Campbell were charged with defrauding shareholders and depositors out of $2 million, and each was sentenced to 15 years at the Walla Walla State Penitentiary.

In 1931, the National Broadcasting Company (NBC) acquired KJR and its three sister stations. But in a 1933 cost-cutting move, NBC leased KJR to KOMO, its local affiliate, for $1 a year. The Fishers combined KOMO and KJR into a single large operation in the Skinner Building, operating them as Western Washington's NBC Red and Blue Network affiliates. This continued until 1945, when new FCC regulations forced the Fishers to sell KJR, which they transferred to Birt Fisher. Retaining KOMO, they soon raised its power to 50 kilowatts and built a model broadcast studio center in the Denny Regrade area. In a few years, it would also be the home of KOMO-TV.

Louis Wasmer was another major player in early Seattle radio. Wasmer, Rogan Jones, and others used Seattle as a radio nursery, starting stations in the city and then relocating them to outlying towns with no local radio service. Wasmer moved KHQ to Spokane in 1925, where it became an important broadcaster. Other radio stations departing Seattle included KVOS, moving to Bellingham in 1926, and KXRO, which moved to Aberdeen the next year. KPQ moved to Wenatchee in 1928. KGEA moved to Longview in 1928, where it became KUJ, and then it moved again to Walla Walla in 1931.

In 1928, Wasmer teamed up with his brother-in-law Archie Taft Sr., who owned Piper and Taft Sporting Goods and had developed an interest in radio by selling crystal sets from his store. Together, they bought KFOA, changed the call sign to KOL, and moved it into the Northern Life Insurance Building. KOL became Seattle's CBS outlet in 1930. In 1937, after losing the CBS affiliation to KIRO, Wasmer, Taft, and Carl Haymond started the Pacific Broadcasting Company, an extension of California's Mutual-Don Lee Network. They paid the line costs to bring Mutual programs to Seattle and then resold the service to other stations. At one point, it was said that Wasmer and Taft controlled half of all Washington's radio stations: their own stations KOL, KGY, KGA, KHQ, and KRKO and their network affiliates KXRO, KVOS, KELA, KMO, KPQ, and KIT.

Kraft's KXA was Seattle's most important independent broadcaster during the 1930s and 1940s. It signed off every day at local sunset to protect a New York station on the same channel but then returned to the air each evening from 10:00 p.m. to 3:00 a.m. local time. As Seattle's only late-night station, it achieved its own popularity with its *Stay-Up Stan, the All-Night Record Man* program.

Moritz Thomsen of the Pacific Coast Biscuit Company, a competitor to Fisher Flouring Mills Co., felt the need to match his competitor's radio activities, so he put KPCB on the air in 1927. But unlike the Fishers, Thomsen never invested in KPCB, and it operated without much local attention until purchased by Saul Haas in 1935. Haas changed the call letters to KIRO and used his ample political influence to get to a better frequency and build the Northwest's first 50-kilowatt

station. He was also able to steal the local CBS affiliation away from KOL and KVI, making KIRO an important source of radio-war news in the 1940s. Under Haas's direction, KIRO grew even more in the 1950s, adding local TV and FM signals.

Dorothy Stimson Bullitt, a Northwest businesswoman and socialite, also bought a small station and built it into a regional broadcast empire. In 1947, she purchased tiny KEVR, changed the call sign to KING, brought in a more professional staff and better programming, and raised the power to 50,000 watts. Soon, there was also a KING-FM, and in 1949 she bought KRSC-TV, Seattle's first TV station, which became KING-TV. In the 1950s and early 1960s, KING Radio rode the height of local popularity with NBC network programs and middle-of-the-road (MOR) music hosted by Al Cummings, Frosty Fowler, Ray Court, and Pat Lewis. Those decades also saw great expansion of the KING empire, adding TV and radio stations in Portland, Spokane, San Francisco, and Honolulu. Bullitt's family business was a powerful broadcast force in the Northwest until her death in 1989 at age 97. Within two years of her death, the company had been dismantled.

All during radio's early years, Tacoma thrived as a separate radio market beneath the shadow of the big Seattle signals. Tacoma's first station was KGB, started in 1922 by Alvin Stenso for the *Tacoma Ledger* newspaper. When Stenso married on July 29, the wedding was broadcast live on KGB—a radio first. But KGB fell silent after the death of the newspaper's owner the following year.

The city's second station was more successful. Howard Reichert's ham station, 7XV, was relicensed to the Love Electric Company in 1922 and renamed KMO. In 1926, Carl Haymond, the former operator of KFC and KFOA, mortgaged his home to buy KMO and moved the transmitter to the Tacoma Rhodes Department Store building. KMO later broadcast from the Hotel Winthrop and the Keyes Building. Haymond ran it for nearly 30 years before selling KMO in 1954.

Tacoma's third station was 50-watt KVI, operated by Edward M. Doernbecher starting in 1927. It increased to 250 watts the next year but had limited operating hours on its 760 frequency. Wanting more, Doernbecher convinced the FCC to order a frequency swap with KXA, giving Tacoma its first full-time 570 frequency in 1932. Now a serious full-time station, Doernbecher rented fashionable studio space in the Rust Building. In 1935, CBS named KVI as its Tacoma CBS affiliate to augment KOL in Seattle. In 1938, when both stations lost their CBS affiliation to KIRO, KVI and KOL filed an unsuccessful conspiracy suit against Saul Haas and Sen. Homer Bone claiming undue influence with CBS. KVI eventually became a Mutual affiliate in 1946.

Ed Doernbecher died in 1936, and his daughter Vernice took over KVI. (In 1938, Vernice married her sales manager and became Vernice Irwin.) KVI's engineer Jim Wallace Sr. (the future owner of KPQ, Wenatchee) convinced her to move the transmitter from Kent to what is now called KVI Beach on Vashon Island, raising the power to 5,000 watts. With this power increase, plus the new saltwater location, KVI now covered Seattle with a local-grade signal. Vernice opened auxiliary studios in Seattle's Olympic Hotel and increasingly edged the station's presence northward. In 1949, KVI was officially relicensed to Seattle and moved full-time into new studios in the Camlin Hotel.

During the 1950s, KVI featured western music and Mutual-Don Lee Network programs. *Sagebrush Serenade* was heard middays, *Chuckwagon Jamboree* was at 5:30 p.m., and *Ranch House Roundup* broadcast at 10:30 p.m. Harry Long was KVI's program director and chief announcer, and Buck Ritchey was its popular country and western DJ for 23 years. In 1959, the Doernbecher family sold KVI to Gene Autry's Golden West Broadcasters, and it moved to the Tower Building at Seventh and Olive Streets. For the next 25 years, KVI was Seattle's dominant personality station, featuring Robert E. Lee Hardwick, Buddy Webber, Jack Morton, Jack Allen, Jim French, Peter Boam, Robert O. Smith, and many others. KVI was also the key station for the Seattle Mariners.

Tacoma's third permanent AM station, KTBI, went live on August 30, 1941, with 250 watts on 1490 kilohertz. Eddie Jensen was the first manager. The KTBI transmitter and studio were in the rear of the Puget Sound National Bank Building, with its tower across the street on the Publix Garage. After the war, KTBI moved into a modern studio building at 2715 Center Street. KTBI was now on 810 kilohertz with 1,000 watts, broadcasting during daytime hours only, owned by

KIRO's former manager Tubby Quilliam, and managed by Ted Knightlinger. In 1952, it became full time on 850 kilohertz, changed its call letters to KTAC, and was sold to a group of local investors led by Jerry Geehan. The power was then increased to 10 kilowatts.

Back in Seattle, Lester Smith became the new owner of KJR in 1954, joined by actor Danny Kaye in 1957. Smith adopted a Top 40 format for KJR, hiring popular disc jockeys like Dick Stokke, Pat O'Day, Larry Lujack, Lan Roberts, and Lee Perkins. KJR quickly shot up to number one and enjoyed a 40 percent local audience share throughout the 1960s. Its competition was KOL, whose personalities included Al Cummings, Les Williams, and Ron Bailie. The two stations battled it out for the teenage and young adult audience through most of the 1960s and 1970s.

KOL changed hands several times during its Top 40 years. In 1963, Archie Taft Jr. sold the station to the owners of the Goodson-Todman TV quiz show production company. They changed the format to MOR for a while but soon switched to the more successful Top 40. In 1967, they sold KOL AM/FM to the Buckley Broadcasting group. During the Buckley years, frequent staff changes and internal turmoil brought about KOL's decline as a top-rated station. Finally, KOL was sold again in 1975 to Sacramento's Hercules Broadcasting Co., and it became country music station KMPS. It competed with KAYO, the former KRSC, run by Jessica Longston since 1952.

FM radio first appeared in the Puget Sound region in 1947 with KING-FM, followed by KRSC-FM and KTNT-FM in 1948, but it languished for more than 20 years. Early FM stations broadcast classical music, elevator music, or just duplicated the programs of their AM sister stations. It began to change in the 1970s, when underground and progressive FM rock formats appealed to younger audiences that were tired of the limited Top 40 genre. Stations like KOL-FM, KISW, KZOK, and KZAM drew large followings. After the birth of National Public Radio in 1970, non-commercial university stations like KUOW and KPLU began to draw mainstream audiences away from the big AM stations. With the introduction of AM/FM car radios, FM stations also began to attract mobile listeners.

But AM was still the money band in the 1970s and 1980s, and the area's leading stations were KIRO, KOMO, and KVI. KIRO became the region's news and information station with important voices like Bill Yeend, Jim French, and Wayne Cody. KOMO and KVI were the personality adult music stations with their dominant morning personalities Robert E. Lee Hardwick and Larry Nelson. KJR maintained its position as Seattle's Top 40 AM station, gradually shifting to an "oldies" format as its audience aged. KING tried Top 40 for a while but eventually lost ground with a variety of unsuccessful formats. New station groups became major players, such as Fred Danz's Sterling Recreation Organization and Ackerley Media.

In 1996, Pres. Bill Clinton signed the sweeping new Telecommunications Act, which, among other things, eliminated the FCC's historical limits on the number of radio stations that could be owned by one entity, both nationally and in a single community. With one stroke of a pen, the face of American radio changed completely. Instead of individual stations run by self-made entrepreneurs, local stations were soon grouped together into clusters run by large investor-driven corporations owning hundreds of stations. Unique, creative programming with personable and sometimes quirky disc jockeys has been largely replaced with sterile, cookie-cutter music formats and politically conservative talk shows. Today, many people miss the entertaining and varied radio of their youth. With the profound changes taking place in today's electronic media, the radio of America's past is probably gone forever.

One

BEGINNINGS

At the start, there were just five men responsible for most of Seattle's early broadcasting.

Vincent Kraft operated Seattle's first station from his Ravenna neighborhood home starting in 1919, using the call sign 7XC. Kraft broadcast phonograph records and piano music and sometimes featured a neighbor child playing the violin. 7XC was relicensed as KJR in 1921. Kraft later built three other West Coast stations and started one of the country's first radio networks. Even after selling his four stations in 1928, he continued to operate Seattle's KXA and two Alaska stations into the late 1930s.

Louis Wasmer ran a motorcycle shop in Seattle and established several of its first stations. He started KHQ in February 1922 with a 10-watt transmitter on the roof of his apartment building. When he built a bigger 50-watt transmitter, he sold his first one to the Economy Market, which went on the air as KZC but only operated for about a year. He also made a transmitter for the Rhodes Department Store station (KDZE) and constructed several more stations that were later moved out of Seattle. He moved his own KHQ to Spokane in 1925 and, combining it with KGA, ran that city's biggest radio operation for several decades.

Carl E. Haymond was the chief operator of the *Seattle Post-Intelligencer* station KFC, Seattle's second radio station. When that station closed, he ran KDZE (later KFOA), the Rhodes Department Store broadcasting station. In 1926, he bought KMO in Tacoma and ran it until 1954; he also built one of the area's first TV stations, KMO-TV.

John Ross was the director of Seattle City Light and a radio aficionado. He built KTW for the First Presbyterian Church and installed the station inside one of the church's rooftop domes. It only broadcast the church's sermons on Sundays.

In July 1924, Roy Olmstead, one of Seattle's biggest bootleggers, started KFQX in his home in the Mount Baker district. But, federal agents suspected the station of broadcasting coded messages to the rum-running boats. On November 17, 1924, prohibition agents raided the home, shutting down the station and arresting Olmstead, his wife, and 15 guests.

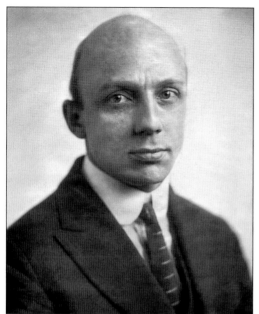

Vincent Kraft was Seattle's first broadcaster. In 1919, he created a local sensation by playing phonograph records over his amateur station 7XC. On July 2, 1920, he broadcast the results of the Dempsey-Carpentier fight for the local audience. Kraft's little station soon became KJR, and he later built stations in Portland, Spokane, and San Francisco. He sold his stations in 1928 but operated KXA in Seattle and two stations in Alaska through the 1930s. (Author's collection.)

Vincent Kraft started transmitting over 7XC in 1919 from the garage of this modest Seattle home at 6838 Nineteenth Avenue NE. He broadcast phonograph concerts for 45 minutes each evening from his 10-watt de Forest transmitter. In 1921, he moved the station, now known as KJR, to his Northwest Radio Service Company store at 609 Fourth Avenue, and shortly afterwards it moved into the Terminal Sales Building. (Courtesy of Ann Wendell.)

This was the original microphone used by Vincent Kraft for his 7XC broadcasts in 1919. Called the Wonderphone, it was originally developed for use with the Dubilier wireless telephone, an early modulated arc transmitter. The microphone was designed to be connected into the antenna circuit and used two or more carbon buttons in parallel to handle the high current. It now belongs to Portland radio collector Sonny Clutter. (Courtesy of Sonny Clutter.)

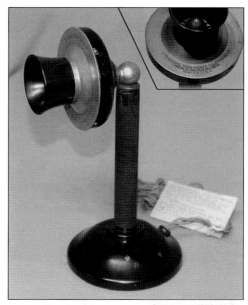

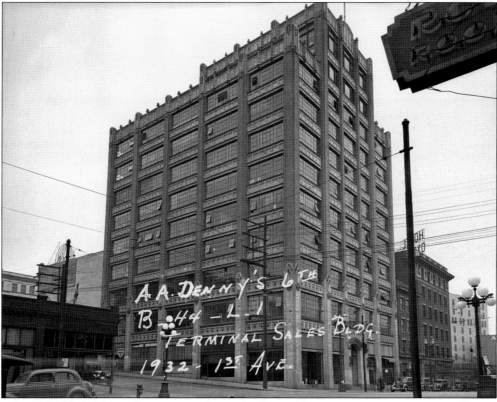

In 1924, KJR moved into the 10-story Terminal Sales Building at 1932 First Avenue in Belltown. Opened in 1923, the building served as a sales and display center for distributors doing business with nearby retailers like Frederick & Nelson and the Bon Marché. The imposing Gothic building is now in the National Register of Historic Places. (Courtesy of the Puget Sound Branch, Washington State Archives.)

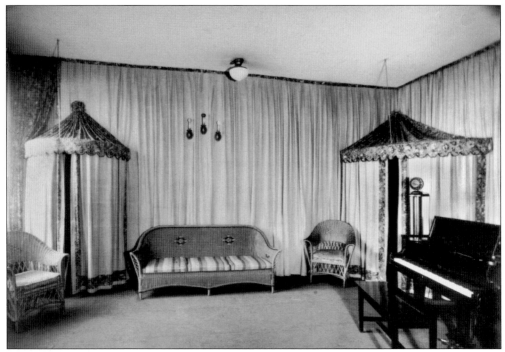

By 1924, KJR had become a serious radio operation, so Vincent Kraft set up studios on the sixth floor of the Terminal Sales Building. Here is the main studio, lined with acoustic draperies and featuring separate isolation booths for the announcer and operator. The three wall sconces were most likely colored signaling lamps operated from the control room. (Courtesy of Howard Kraft.)

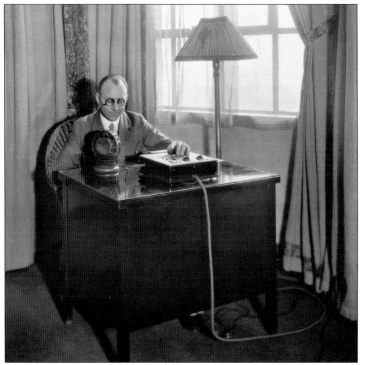

A KJR announcer sits at the studio desk in the Terminal Sales Building. He uses the control panel in front of him to turn on his microphone and signal the operator. The Western Electric 600A double-button carbon microphone on the desk was the classic studio microphone used by most stations in the 1920s. (Courtesy of the Museum of History and Industry.)

This was KJR's 1,000-watt transmitter on the 10th floor of the Terminal Sales Building. It was custom made for the station by Vincent Kraft's Northwest Radio Service Company. The antenna stretched from the back of the building over to the top of the St. Regis Hotel at Second and Stuart Streets, crossing diagonally to the opposite corner of the block. (Courtesy of Howard Kraft.)

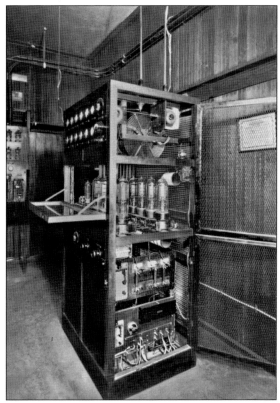

Station KZC was licensed by the Public Market and Market Stores Co. on April 20, 1922. It was located in the Economy Market Building at the southwest corner of First Avenue and Pike Street—today's Pike Place Market. KZC was unsuccessful because of low power and limited hours, and it was off the air by April of the following year. This photograph of the Economy Market building is from 1937. (Courtesy of the Puget Sound Branch, Washington State Archives.)

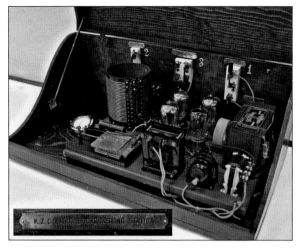

This crude radio transmitter was built by radio and motorcycle enthusiast Louis Wasmer for his own station, KHQ (which he later relocated to Spokane). When he built a bigger transmitter for KHQ, he sold this one to the Economy Market. When KZC closed, the transmitter was pushed aside, forgotten, and eventually sealed up inside a wall. It was uncovered during the remodeling in 1962 and donated to the Museum of History and Industry (MOHAI). (Photograph by George Walford, courtesy of the Museum of History and Industry.)

KTW was built by John D. Ross, head of Seattle City Light, to broadcast the sermons of his pastor, the controversial the Reverend Mark A. Matthews of the First Presbyterian Church. Ross, an important city civic leader and radio enthusiast, made the 250-watt transmitter used by the station. Here is Ross at his desk at Seattle City Light in May 1930. (Courtesy of the Seattle Municipal Archives.)

A fiery fundamentalist preacher, the Reverend Mark Matthews came to Seattle from Jackson, Tennessee, in 1902 and headed the First Presbyterian Church for 38 years. As his fame spread, the congregation grew from 1,000 in 1903 to 8,000 by 1940, becoming the largest Presbyterian Church in the world. He was one of the first ministers to use radio, seeing it as a way to extend his message beyond the church building, which filled to capacity every Sunday. (Courtesy of the Museum of History and Industry.)

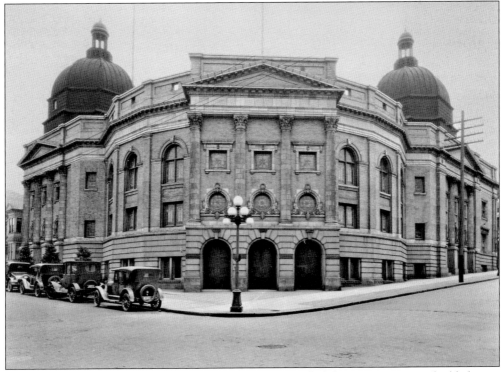

When Ross built KTW at the Presbyterian church, he installed the transmitter in a shielded room inside the church dome seen to the left in this view, with a wire antenna suspended between the domes. KTW was licensed April 14, 1922, and began transmitting regular weekly programs (Sundays only) on May 14. The church continued to operate KTW until 1964, sharing a frequency with KWSU in Pullman. KTW is now KKDZ. (Author's collection.)

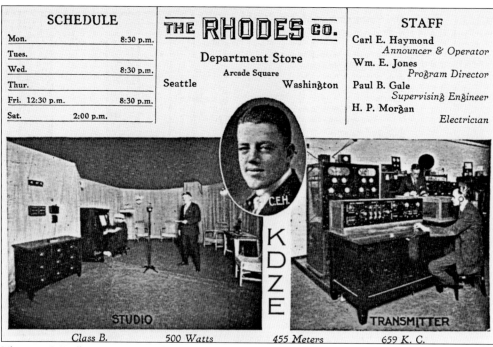

SCHEDULE		THE RHODES CO.	STAFF
Mon.	8:30 p.m.		Carl E. Haymond
Tues.		Department Store	*Announcer & Operator*
Wed.	8:30 p.m.	Arcade Square	Wm. E. Jones
Thur.		Seattle Washington	*Program Director*
Fri. 12:30 p.m.	8:30 p.m.		Paul B. Gale
Sat.	2:00 p.m.		*Supervising Engineer*
			H. P. Morgan
			Electrician

KDZE

STUDIO TRANSMITTER

Class B. 500 Watts 455 Meters 659 K. C.

This is a QSL (listener response) card for KDZE, one of Seattle's first radio stations. Operated by Rhodes Department Store in downtown Seattle, KDZE opened on May 17, 1922, operating just a few hours a day as one of eight stations sharing time on 360 meters. By 1924, KDZE had become KFOA and had 500 watts on 660 kilohertz. Station operator Carl E. Haymond (shown here as "C.E.H.") later bought Tacoma's KMO and ran it for many years. (Author's collection.)

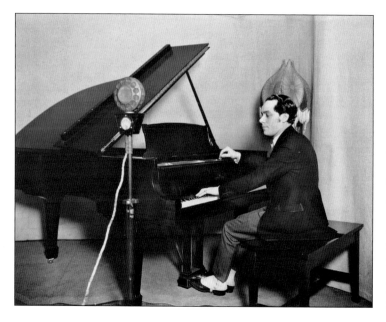

An unidentified pianist is performing in the KFOA studio in Rhodes Department Store. Shoppers could visit the second floor of the store and watch radio broadcasting in action. In 1927, KFOA became the Seattle affiliate of the new National Broadcasting Company (NBC) Pacific Coast Network, carrying the network's first live programs from San Francisco. (Courtesy of the Museum of History and Industry.)

This view of the KFOA studio in 1925 shows the station announcer and microphone. The announcer is striking a suspended pipe chime, which was the station's signature sound on the air. The entire studio is wrapped in heavy monk's cloth fabric to deaden the room's acoustics. A meter on the microphone shows the broadcast sound level, and signal lights on the wall tell the performers when they are on the air. When it first opened as KDZE, the station's operating schedule was limited by frequency time-sharing: 3:15–4:00 p.m. daily except Sunday and also 7:15–8:15 p.m. Monday, Wednesday, and Friday nights. By 1924, now known as KFOA, it had its own frequency of 1110 kilohertz with 100 watts and increased operating hours. In 1925, it moved to 660 kilohertz and increased again to 500 watts, and then the following year it increased again to 1,000 watts, considered very high power for its time. (Courtesy of the Museum of History and Industry.)

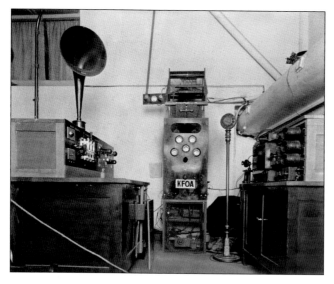

This is the KFOA transmitter room in Rhodes Department Store. The homemade transmitter is at the rear with its control panel to the left, and the audio control console is on the right. KFOA was Seattle's only Class B station, which was the highest class of license issued by the US Department of Commerce. Class B stations were required to operate with at least 500 watts of power, and all programs had to be live. KJR and KTW also became Class B stations in 1924. (Courtesy of the Museum of History and Industry.)

Roy Olmstead, a former Seattle policeman, was the "King of the Puget Sound Bootleggers" in the 1920s. He was also one of the area's first radio broadcasters. In 1924, Olmstead married his second wife, Elise, and they established the American Radio Telephone Company, operating station KFQX from their opulent Mount Baker home, dubbed the "Snow White Palace" at 3757 Ridgeway Place in Seattle. Here are Roy and Elise in 1925. (Courtesy of the Museum of History and Industry.)

Alfred M. Hubbard, a young radio engineer, was Olmstead's partner in KFQX. He built the station's 1,000-watt transmitter, which was installed in a spare bedroom of the Olmstead home. However, Prohibition Bureau agents were able to turn Hubbard into a secret informant in exchange for a job offer to become a Prohibition agent. (Courtesy of the Museum of History and Industry.)

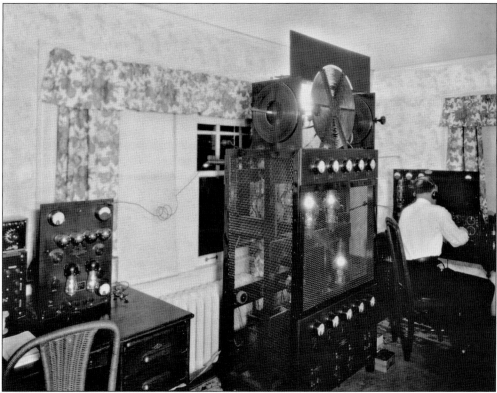

Engineer Nick Foster operates the KFQX transmitter in the Olmstead home in 1924. Drawing from Hubbard, other informants, and wiretaps, Prohibition agents raided the home on November 17, 1924, shutting down the radio station and arresting Roy Olmstead, his wife Elise, and 15 guests. Elise was acquitted, but Roy was convicted and served four years at McNeil Island Penitentiary. Foster later worked as a broadcast engineering instructor at Edison Technical School. (Courtesy of the Museum of History and Industry.)

In his business travels to Canada, Roy Olmstead met a young English woman named Elise Campbell and married her in 1924. Elise was the person who actually ran KFQX, which broadcast for four hours each evening. The programs began at 6:30 p.m. with news, weather, and stock market reports and concluded with a live remote broadcast of the Earl Gray Orchestra from the Butler Hotel Cafe. In between the two programs, Elise herself was heard at 7:15 p.m. as "Aunt Vivian," hosting a popular program of children's bedtime stories. Federal Prohibition agents suspected that Elise's broadcasts were actually coded messages being used to send instructions to the Olmstead rumrunning boats in the Puget Sound. This was reported in the *Seattle Star* and became a local broadcast legend, but it was always denied by Nick Foster. He said he often bought her children's books during the day and gave them to her just a few minutes before airtime; nonetheless, it was justification for the agents to shut down the station when they raided the Olmstead home. (Courtesy of the Museum of History and Industry.)

Two

Fisher's Blend

In March 1925, Birt F. Fisher leased Olmstead's KFQX and returned it to the air as KTCL ("The Charmed Land"), moving the transmitter to Magnolia Bluff with studios in the New Washington Hotel. Fisher attempted to broadcast quality local programs but continually suffered financial and technical setbacks. In April 1926, KTCL was evicted from the hotel and fell silent for several weeks while moving to the Home Savings Building.

But the worst of Fisher's problems came in May 1926. To pay his $8,000 liquor law violation fine, Roy Olmstead sold KCTL to Vincent Kraft, the owner of KJR, for $10,000. Kraft planned to take over the station once Fisher's lease expired in December.

Fisher scrambled to find a solution to his dilemma. He knew that one of the owners of Fisher Flouring Mills Co., Oliver David "O.D." Fisher (no relation), was a big radio fan, so he approached the Fisher family seeking financing for a new station. O.D. and his brother Will agreed to form Fisher's Blend Station, Inc., owned 66 percent by the Fisher brothers and 34 percent by Birt Fisher. Their plan was to transfer the KCTL operations to a new station when the lease expired. A new Western Electric 1,000-watt transmitter was installed at the Fisher flour mill. Temporary studios were set up in the 303 Westlake Square Building until permanent facilities in the Cobb Building could be ready the following year. The new station debuted as KOMO on New Year's Eve in 1926 with an all-day inaugural extravaganza involving over 250 people, including a new, full-time KOMO orchestra. That same week, Kraft took over the old KTCL and changed it to KXA.

KOMO was designed to be a promotional vehicle for Fisher's Blend flour, which sponsored a part of the program schedule. For the remaining time, a new corporation named the Totem Broadcasters was formed, owned by 12 of Seattle's largest businesses. Each member committed to sponsor part of the remaining airtime in exchange for air mention.

With a staff of 65 producing 14 hours of live programs a day (and eventually becoming the local NBC affiliate), KOMO quickly became one of Seattle's most popular stations.

Birt Farrington Fisher (1886–1961) leased the Olmstead station KFQX in 1925, changing it to KTCL. In 1926, he joined with O.D. Fisher to form Fisher's Blend Station and open a new station, KOMO. Birt Fisher became the manager of the new station. In 1933, Fisher's Blend leased KJR from NBC and purchased it in 1941. When the FCC forced the two stations to separate in 1945, Birt Fisher became the sole owner of KJR. (Courtesy of Homer Pope.)

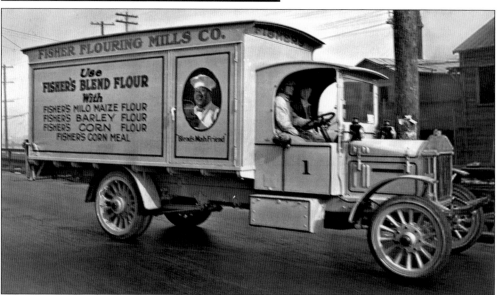

Brothers O.W. and O.D. Fisher opened the Fisher Flouring Mills Co. on Harbor Island, an artificial island at the mouth of the Duwamish River in Elliott Bay, in 1911. There, the company milled Northwest wheat into flour each day for distribution around the world. Here is one of the company's new 11.5-ton delivery trucks on West Spokane Street near Whatcom Avenue in 1918. (Courtesy of the Seattle Municipal Archives.)

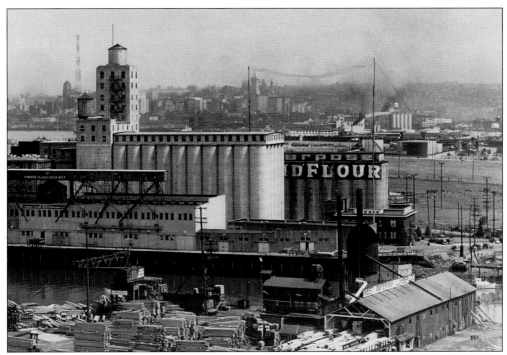

The Fisher flouring mill was a prominent landmark on the Duwamish Waterway and was also the location the Fisher family chose for its KOMO antenna in 1926, seen here suspended between two wooden poles. The brick building at right housed the transmitter. (The KOL tower can be seen in the background.) This antenna was replaced in 1937, but the mill buildings and silos are still in use today. (Author's collection.)

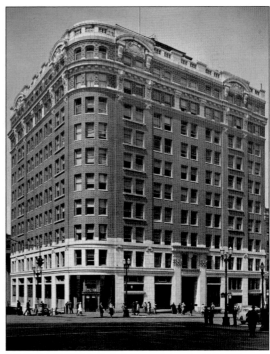

In 1927, KOMO moved into basement studios in the Cobb Building at Fourth Avenue and University Street. This imposing Beaux Arts edifice was constructed in 1910 by the Metropolitan Building Company, in which the Fishers were investors. In 1933, KOMO took over the operation of KJR, and both stations moved into the Skinner Building. KIRO then occupied the Cobb Building studios through the 1940s. The Cobb Building was converted into apartments in 2005. (Courtesy of the Seattle Public Library.)

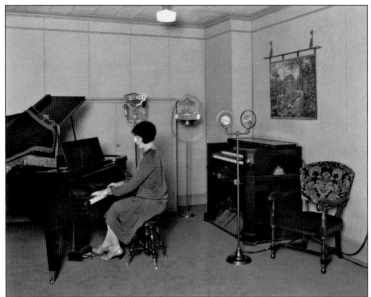

An unidentified pianist performs in the KOMO studios in the Cobb Building. Seen in this view are a piano, organ, a signaling lamp fixture, and a birdcage. The frequent sound of canaries singing in the background was an audio signature of early KOMO. (Courtesy of the Museum of History and Industry.)

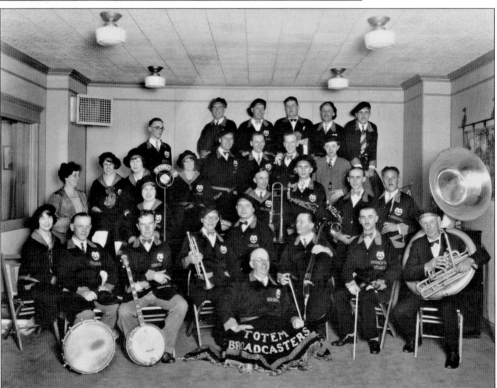

The entire KOMO program staff assembled for this group photograph in the Cobb Building studio about 1927. The "Totem Broadcasters" banner has significance. In the beginnings of KOMO, O.W. Fisher formed a production company by that name, operated by 12 of the largest businesses in the area. Each company guaranteed a certain amount of sponsorship, and together the group took responsibility for producing all of KOMO's local programming. (Courtesy of the Museum of History and Industry.)

Here is the KOMO master control room in the Cobb Building around 1927. The control operator selected the studios and microphones to be broadcast and controlled the overall program volume. A paper cone monitor speaker is at center left. KOMO joined the NBC Pacific Coast network in 1927, and the telegraph keys and sounder visible here were probably for communicating with other network stations via a telegraph order wire. (Courtesy of the Museum of History and Industry.)

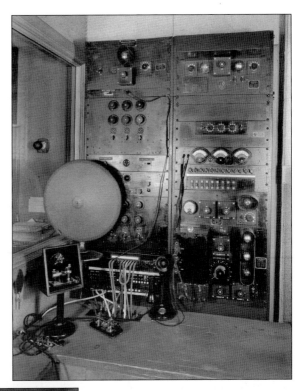

Here is *Seattle Post-Intelligencer*'s sports editor and local sporting icon Royal Brougham interviewing boxer Jack Dempsey on KOMO during the late 1920s. Dempsey, the "Manassa Mauler," was the losing protagonist in two historic boxing matches against Gene Tunney that were broadcast nationwide in 1926 and 1927, making him one of radio's earliest celebrities. The large tubular fixture between them is an early condenser microphone. (Courtesy of Homer Pope.)

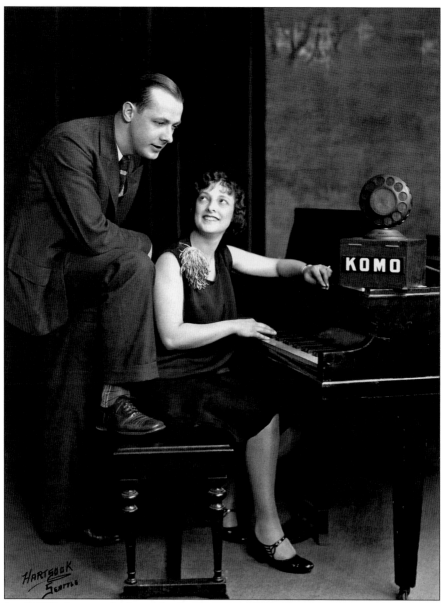

This April 1929 photograph shows Art Lindsay and Gladys Everett, who were heard on KOMO as the Harmony Team. All of KOMO's programs were broadcast live from the start and consisted mainly of live music shows. KOMO was said to be the largest employer of musicians in the state. Fully half of the local programs featured serious music, and variations of traditional and popular music filled the remaining time. Sponsorship messages were heard every 10 minutes or so, simply declaring that the next segment was presented "in the interest of" the sponsoring company. The public was adverse to the idea of broadcast advertising in the first days of radio, and so very little selling actually took place on the air. The ads were more like the underwriting announcements heard on public radio today. Soon after its debut, KOMO became one of the first stations to join the National Broadcasting Company's West Coast Orange Network. Live network programs from San Francisco were heard in the evenings, and with time the network gradually expanded to fill more of the broadcast day. (Courtesy of the *Seattle Post-Intelligencer*.)

Three

ADOLPH LINDEN AND THE ABC NETWORK

The only other station in town that could rival KOMO was KJR. Its owner, Vincent Kraft, had built three other stations: KYA, in San Francisco, KEX in Portland, and KGA in Spokane, and he tied them together in 1926 to create one of the first networks. In 1928, he sold all four stations to Adolph F. Linden, co-owner of the ritzy new Camlin Hotel with Edmund Campbell. Both men were also directors of Puget Sound Savings & Loan. KJR was immediately one of the most popular and best-financed radio stations in the Northwest. It had a large program staff, including announcers, singers, a dance band, and a symphony orchestra.

Linden joined forces with the Columbia Broadcasting System (later CBS) to distribute the network's programs west of Omaha. On certain nights, Columbia would relay Seattle programs to the East Coast. The new 14-station network was called the American Broadcasting Company (unrelated to today's ABC network).

In 1928, it was discovered that Linden and Campbell had been borrowing money from their savings and loan association to run the station and finance their hotel project. A secret agreement was signed for the partners to repay $1.5 million to the bank, and Linden resigned his position as president of the bank, only to be replaced by Campbell.

In the summer of 1929, Linden promoted a popular series of outdoor summer concerts "under the stars" from a stage on the University of Washington football field. Some of the nation's top classical musicians converged on Seattle, including directors Meredith Willson and Alfred Hertz. Live outdoor concerts were broadcast three nights a week over KJR for several weeks, but Seattle's predictably rainy weather resulted in dismal public attendance. Finally, without warning, the savings and loan association filed for bankruptcy in August, and the money stopped flowing abruptly. The network lines were shut down for nonpayment. CBS took them over and established a new West Coast network with Los Angeles broadcaster Don Lee. Most of KJR's staff and musicians left when their paychecks stopped. Grand pianos were repossessed. The receiver-in-bankruptcy advanced $50 so the station could buy phonograph records.

Grasping for a solution, Adolph Linden negotiated a sale of the radio stations and the ABC network to Twentieth Century Fox. On October 15, 1929, he and his family headed out to New York by car to sign the deal; however, while they were en route, the stock market crashed, and the deal was dead on their arrival. An arrest warrant brought Linden back to Seattle, where both he and Campbell were charged with defrauding shareholders and depositors out of $2 million. They each received 15 years in the Walla Walla State Penitentiary.

In 1927, Vincent Kraft moved KJR from the Terminal Sales Building to the Home Savings Building at 1520 Westlake Avenue. Formerly the American Hotel, it had recently been remodeled and reopened as prime office space on the five-corner intersection of Westlake Avenue, Fourth Avenue, and Pine Street. In this 1925 view from the Medical Dental Building, the Home Savings Building is visible in the center. The Bigelow Building across the street was home to Kraft's other station, KXA. (Courtesy of Ron Edge.)

KJR's chief engineer Clarence Clark is seen in the master control room in the Home Savings Building. Clark started with KJR in 1926 and supervised the company's transmitter installations in Seattle, Portland, and Spokane. In later years, he worked for KXL in Portland and KSLM in Salem before returning to Seattle and KOMO in 1934. Clark passed away in 1959. (Courtesy of Homer Pope.)

In May 1926, Vincent Kraft told the local newspapers he was looking for a more favorable location for the KJR transmitter on the north end of the city: "I am looking for a good site for the two steel towers which will support our new antenna system. We are not satisfied with the results obtained in our downtown location." The next year, the facility shown here was completed at Fifteenth Avenue NE and NE 185th Street in Lake Forest Park, concurrent with KJR's move to the Home Savings Building. A new brick transmitter building and two self-supporting towers were constructed to support the characteristic flattop T wire antenna of the era. KJR operated from here until 1937. It is now the location of St. Mark Catholic Church. (Both, courtesy of the Museum of History and Industry.)

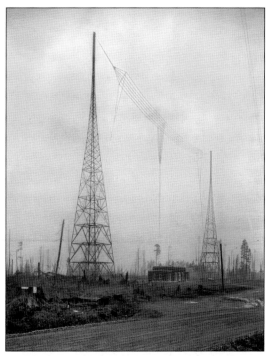

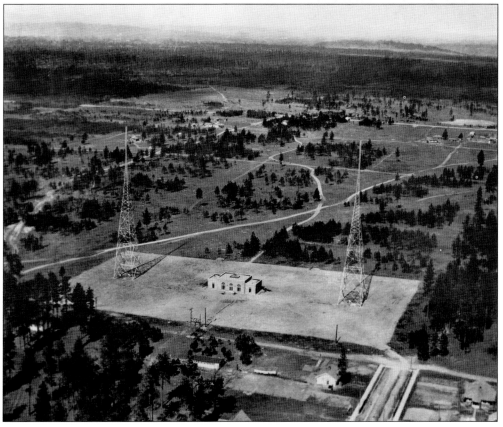

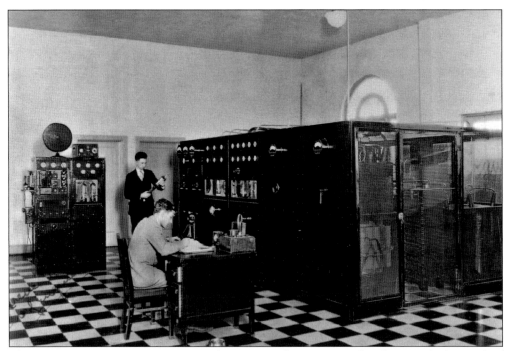

This was KJR's new transmitter near Lake Forest Park in 1927. In the photograph above, chief engineer Clarence Clark is standing, while chief operator Mr. Fesidnor is seated. KJR initially operated this transmitter at 2,500 watts, but the power was later raised to 5,000 watts. The transmitter, possibly built by Vincent Kraft's Northwest Radio Service Company, was similar to other transmitters that Clark later installed in Portland and Spokane. In the image below, Clark is showing the station's new transmitter to Victor Rivers in 1927, pointing to the transmitter's final amplifier tubes. Separate audio cabinets with their modulator tubes are to the left, and the monitor speaker and modulation monitor are on top of the cabinets. Victor Rivers was a University of Washington engineering student in 1927 and later became an Alaska state senator. (Both, courtesy of Homer Pope.)

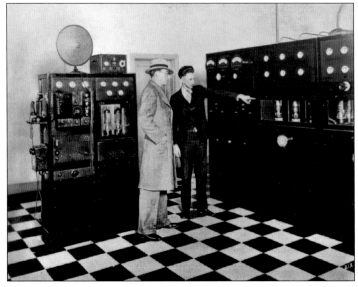

Adolph Linden was the president of KJR and the ABC Western network in 1929. He and his partner Edmund Campbell were also directors of the Puget Sound Savings & Loan, and they financed their radio operations with borrowed bank money. When the bank declared bankruptcy in 1929, the two men were charged with defrauding shareholders and depositors out of $2 million. Each man was sentenced to 15 years at the Walla Walla State Penitentiary. (Author's collection.)

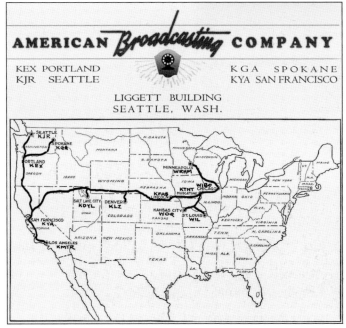

These were the American Broadcasting Company's stations in 1929. The network opened December 22, 1928, with a three-hour program sponsored by Union Oil. Afterward, programs originated on alternate nights from Seattle and San Francisco. In January, the network was extended to Salt Lake City, Denver, Omaha, and Chicago, where it connected with the Columbia Broadcasting System. ABC and CBS established a reciprocal program exchange, which brought Seattle programs to the East Coast. (Courtesy of Homer Pope.)

A KJR pianist, probably Mabel Mohrajan, is seen performing in Studio B in the Home Savings Building about 1928. The studio was hung in heavy draperies for control of acoustics, but it also had the comfortable appointments of a 1920s living room to help put nervous performers at ease. The only radio devices in the room were the microphone and announcer's control desk in the corner. (Courtesy of Museum of History and Industry.)

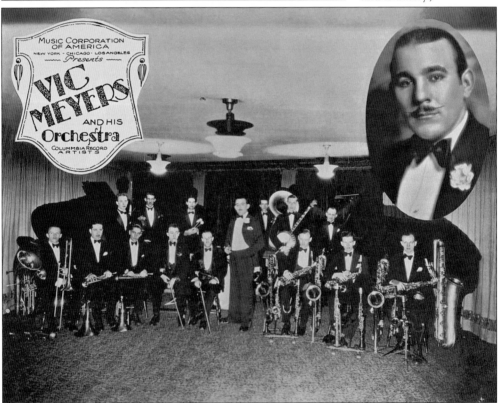

Vic Meyers and his 10-piece orchestra recorded for Brunswick Records and performed at the Butler Hotel and the Trianon Ballroom, Seattle's leading dance salons during the Prohibition years. They were heard from 6:00 p.m.–7:00 p.m. and 10:00 p.m.–12:00 a.m. daily on KJR and the ABC network during 1929. Here is the Vic Meyer Band in KJR's Studio B around 1929. Meyers later served as the lieutenant governor for 20 years, plus another eight years as secretary of state. (Courtesy of Homer Pope.)

Bob Nichols started as a singer on the P-I station KFC in 1921. By 1927, he was KJR's sports director and doing some of Seattle's first play-by-play broadcasts. In this photograph given to coworker Homer Pope, his image is superimposed on a microphone of the era. The autograph reads, "Broadcasting best wishes to Homer Pope. We're friends even when the 'mike' is off balance and the cord doesn't reach." (Courtesy of Homer Pope.)

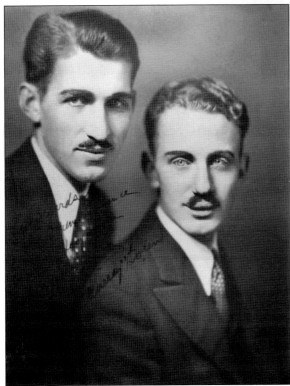

Murray Bolen (right) was an announcer at KFI in Los Angeles in 1928. He put together vaudeville music and a comedy act with Harris Brown (left), an old school chum, and they came north to Seattle. The team was heard on KJR and the ABC network until it went bankrupt, and then it moved to KFRC in San Francisco. Bolen later produced some of network TV's biggest shows in the 1950s. (Courtesy of Homer Pope.)

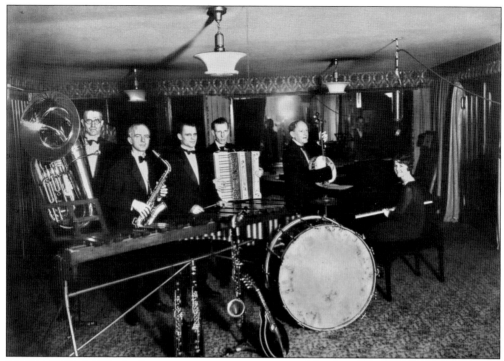

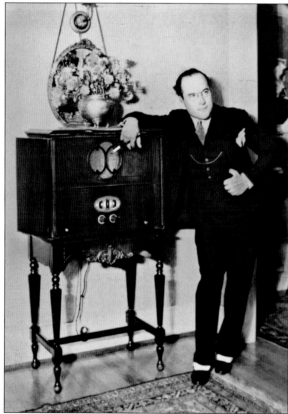

The Gauchos were a musical group that performed on KJR. The members are pictured in Studio B around 1931 or 1932. Two microphones are suspended from the ceiling, and the studio operator can be seen in the background. Some of the KJR musical programs employed a musician in the control room who followed the musical score and told the operator when to adjust the volume for a consistent audio level. (Courtesy of Homer Pope.)

Serious music was also an important part of KJR's programming. The station's 20-piece American Salon Orchestra broadcast daily on KJR and the American Broadcasting Company. Its director was the Italian-born pianist Francesco Longo. He came to Seattle from New York, where he had been director of the Manhattan Opera Company. He is seen here with a highboy console radio in his Broadmoor home about 1929. (Courtesy of Homer Pope.)

Adolph Linden spared no expense to bring the country's finest musicians to Seattle for KJR's summer concert broadcasts in 1929. Mischa Mischakoff (left), one of the nation's leading violinists, led the Mischakoff Quartet (Ennio Bolognini, cello; Jascha Veissi, violin; and Leon Barzin Jr., viola). But, the mounting costs finally brought down Linden's financial house of cards, and many musicians left Seattle without being paid. (Courtesy of Homer Pope.)

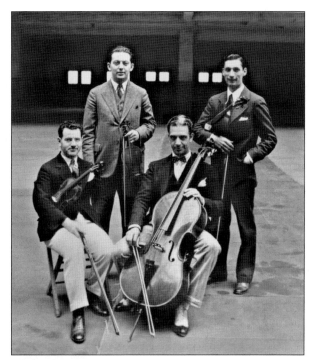

In 1928, Adolph Linden brought Meredith Willson, a young New York flautist, to Seattle to be ABC's music director. Linden wanted to start his own full orchestra to perform for his 1929 summer concert broadcasts. He named Willson as the conductor, who returned to New York and enlisted his musician friends for a 20-week engagement in Seattle. But, when finances collapsed, the musicians went home owed over $100,000. Willson went on to a big future in radio and motion pictures. (Author's collection.)

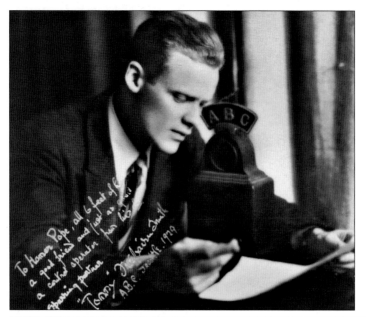

Scottish-born announcer Thomas Freebairn-Smith was the studio director for KJR and the ABC network. When the station went bankrupt, he pleaded on the air for help and managed to get a listener to donate an old upright piano. He was later an announcer at KNX in Los Angeles, where he was heard on some CBS programs. His acting credits in the 1960s included supporting roles on the *Perry Mason* television series. (Courtesy of Homer Pope.)

Northwest Broadcasting System, Inc.

General Offices
HOME SAVINGS
BUILDING
SEATTLE

K J R SEATTLE
K G A SPOKANE
K E X PORTLAND
K Y A ... SAN FRANCISCO

K J R Seattle

Dear Friend:

 We are indeed pleased to receive your report of reception of our broadcast. It is gratifying to hear from our listeners to know that they enjoy our programs and appreciate our efforts towards their entertainment. We trust you will be with us daily.

We thank you,

NORTHWEST BROADCASTING SYSTEM, Inc.

Studios and Offices
HOME SAVINGS BUILDING
SEATTLE, WASH.

Operating Radio Stations
KJR Seattle 5000 Watts 970 Kilocycles 309.1 Meters
KGA Spokane 5000 Watts 1470 Kilocycles 204. Meters
KEX Portland 5000 Watts 1180 Kilocycles 254.1 Meters

JURY CONVICTS AHIRA PIERCE

SEATTLE, Sept 9. (P) Ahira E. Pierce, foprer vice president of the defunct Home Savings and Loan association, was convicted by a superior court jury here Thursday after less than an hour's deliberation on a charge of publishing a false financial statement of a subsidiary concern.

Sentence will be passed September 7. Pierce, ill, heard the verdict while reclining in the wheel chair in which he had been brought into court.

In 1930, Linden's three Northwest stations (KJR, KEX, and KGA) were sold out of receivership to Ahira "Hi" Pierce, the owner of Home Savings & Loan. Under his direction, the remnants of the old ABC network resurfaced as the Northwest Broadcasting System (NBS), serving the three stations with programs originating from KJR. But, in a bizarre repeat of history, Home Savings & Loan also went bankrupt, and Pierce was also jailed for misappropriation of funds. (Author's collection.)

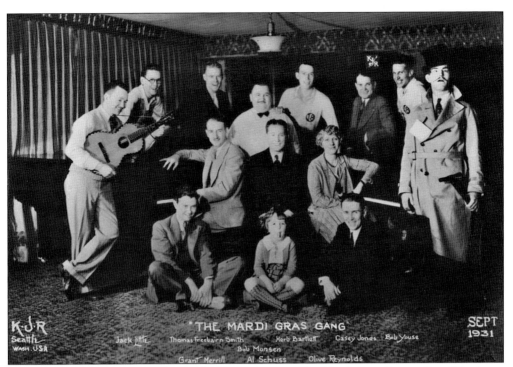

The biggest program on KJR during the NBS years was *The Mardi Gras Gang*, a live, 90-minute variety show heard in 1931. The cast was mostly drawn from the station's regular staff. It offered a variety of popular music mixed with skits featuring wacky comedic characters. This was a program concept that was also enjoying success at stations in other cities, such as the KGW *Hoot Owls* in Portland. (Courtesy of Homer Pope.)

Grant Merrill, a popular pianist at KJR starting in 1928, was one member of *The Mardi Gras Gang* cast. By 1937, he had become the production director for KOMO and KJR, and he remained with the stations through the 1940s. This publicity photograph was taken during his first year at KJR. (Courtesy of Homer Pope.)

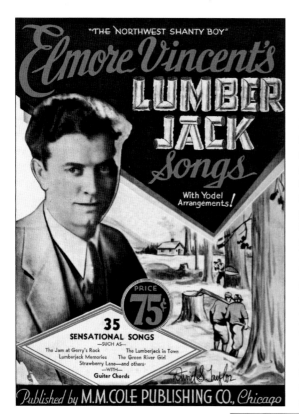

Elmore Vincent was a sawmill worker from Tacoma who dreamed of becoming a radio singer. After his ninth audition at KJR, he was finally hired in 1929 for a modest $32.50 per-week salary. He first appeared on *The Mardi Gras Gang* program (bottom left in *The Mardi Gras Gang* photograph on previous page) as the Northwest Shanty Boy, singing lumberjack songs in a tenor voice with yodel arrangements. Looking for an additional role on the program, Vincent created a new comedy character: the word-mangling Sen. Frankenstein Fishface. He was an instant hit. In 1934, NBC asked Vincent to bring his Fishface character to San Francisco to join the cast of Meredith Willson's *Carefree Carnival* network show. (Both, author's collection.)

Four

KJR and KOMO

After Home Savings & Loan went bankrupt, KJR and the other NBS stations were acquired by the National Broadcasting Company. NBC, which operated the Red and Blue Networks in the East, also served the Pacific Coast with the Orange Network from San Francisco. The four Northwest stations became part of a second Pacific Coast Network, the Gold Network, but Depression budget cuts caused the network to reverse course and discontinue the Gold Network in 1933. To get the money-losing Northwest stations off its books, it leased each of the stations to its local NBC affiliates for $1 a year. It resulted in KJR being combined with KOMO in 1933 under the management of the Fisher's Blend Station. All KJR programs were locally produced until 1936, when NBC finally extended both its Red and Blue Networks to the West Coast and KJR became the Blue Network affiliate.

KOMO lacked enough space for both stations in the Cobb Building, so in 1934 it moved to new studios on the seventh floor of the Skinner Building. The station boasted that it had the finest broadcast facility west of Chicago. Four studios allowed for simultaneous KOMO and KJR broadcasts plus rehearsals. Then, in 1937, a new transmitter building and 570-foot, self-supporting tower were constructed on the West Seattle Waterway, and both stations now operated from the same tower. The entire project, including the building, tower, and two new five-kilowatt transmitters represented a $223,000 investment by the Fishers.

In 1941, Fisher's Blend Station purchased KJR outright, ending the eight-year lease. But, in 1944, a new FCC duopoly rule prohibited the common ownership of more than one station in a community. Foreseeing the need to sell off KJR, the Fishers swapped frequencies between the stations, giving KOMO the better 1000-kilohertz frequency and moving KJR to 950. In 1945, they divested of KJR through a stock swap, and Birt Fisher ended up as KJR's sole owner. While KJR stayed in the Skinner Building, KOMO made plans to build a grand new broadcast center and applied to increase its power to 50 kilowatts.

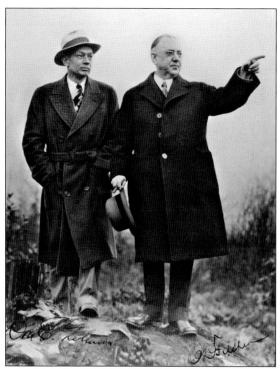

O.D. Fisher was the principal owner of Fisher's Blend Station, which owned and operated KOMO. In 1933, Fisher's Blend leased KJR from NBC for $1 a year and operated both stations from studios in the Skinner Building. O.D. (right) is seen here with Don E. Gilman, the western division manager of NBC, in the 1930s. (Courtesy of Homer Pope.)

This was the Skinner Building at 1326 Fifth Avenue shortly after its completion in 1928. The Fifth Avenue Theater was on the ground floor, and the KOMO-KJR studios were on the two top floors. The Fisher family was a major investor in the Metropolitan Building Company, the developer of the Metropolitan Tract in downtown Seattle, which owned the Skinner Building. (Courtesy of Museum of History and Industry.)

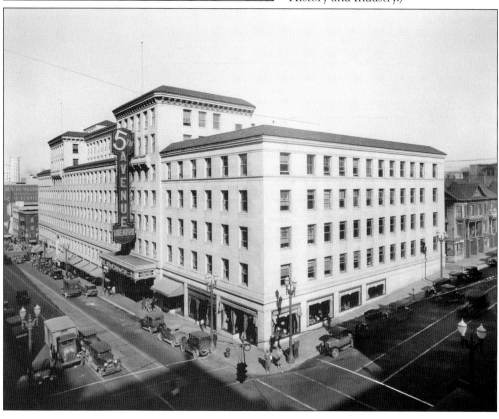

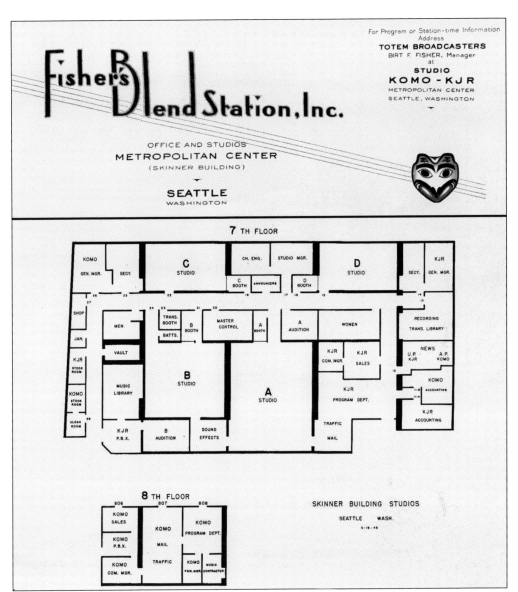

This floor plan shows the layout of the Skinner Building studios. KOMO and KJR shared the four studios, equipment, and staff, and programs could be fed from any of the studios to either station. Studios C and D were large enough for full orchestras or dramatic casts but were mostly the source of piano performances and news programs. The big A and B studios, used for live productions, floated on six inches of balsa wood to isolate them from any outside sounds. The studio walls were covered with a Weyerhauser acoustic material called Nuwood. All of the sound-effects props and the rolling turntable cart were kept in the sound-effects room, which opened onto both of the large studios. KOMO and KJR took advantage of the new location to make frequent live broadcasts from the Fifth Avenue Theater on the first floor. (Courtesy of Homer Pope.)

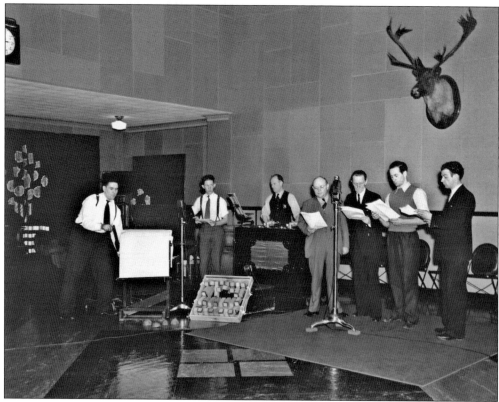

This 1937 photograph shows the KOMO-KJR staff rehearsing for a broadcast in Studio A of the Skinner Building. A mobile turntable cart is used to produce recorded sound effects, and a number of devices for the creation of live effects are on hand. Seen from left to right are Howard Edelson, Doug Setterberg, John Nickerson, Leon Cluff, Lionel Dobell, Rollin Neibauer, and Robert Decker. (Courtesy of Museum of History and Industry.)

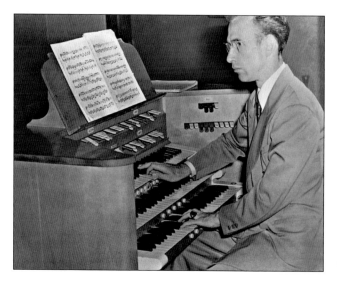

In October 1939, a new Wurlitzer three-manual pipe organ was installed in Studio B of the Skinner Building. The custom-built instrument was installed by Balcolm and Vaughn, Seattle master organ builders. The entire console was mounted on wheels to make it movable within the studio. The complete installation took 11 weeks. Ed Zollman is seen here at the keyboard, but Eddie Clifford was also frequently heard on the instrument. (Courtesy of Puget Sound Theater Organ Society.)

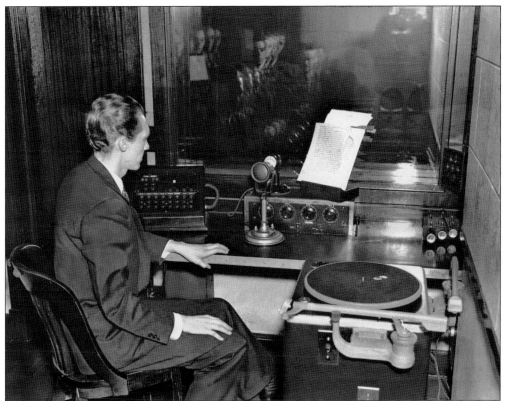

Each KOMO-KJR studio had a control booth that oversaw the performance through a plate-glass window. Clinton Johnson is pictured in one of the booths in 1937. Each room had a small mixing console, turntable, microphone, and a switching control box that selected outside program sources (network or remote broadcast phone lines) and could feed programs to either station. Station breaks between network programs were a one-man operation done from these rooms. (Courtesy of Museum of History and Industry.)

This was the KOMO-KJR master control room in 1937. This operator was responsible for the final quality and routing of the program audio as it left the building and went to the transmitters of both stations. He could also switch rehearsal audio to the audition rooms or send audio from any studio to the transcription room for recording. The master control operators had window views into the two large studios. (Courtesy of Museum of History and Industry.)

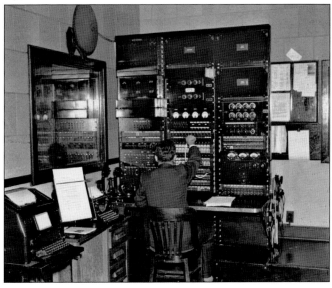

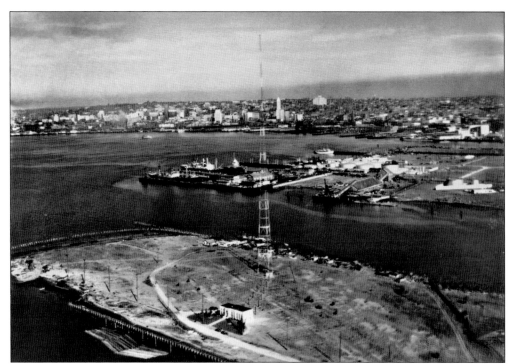

This 573-foot tower on the West Seattle Waterway was completed late in 1936. It was a shared transmitter site for Fisher Broadcasting Company's two stations, KOMO and KJR, and both operated with 5,000 watts from the same tower. The aerial view above was taken after the tower's completion and shows some of Seattle's "Hooverville" squatter's cabins at the water's edge. Compare this with the view below from December 1964. In 1948, KOMO increased its power to 50,000 watts and moved to a new transmitter site on Vashon Island. KJR continued to operate from this tower and later moved its studios to the site in 1955. The image below shows a small second tower that was added to allow KJR to increase its nighttime power. KJR finally vacated the site in 1996, and the landmark Truscon tower was dismantled in 2000. (Both, courtesy of Homer Pope.)

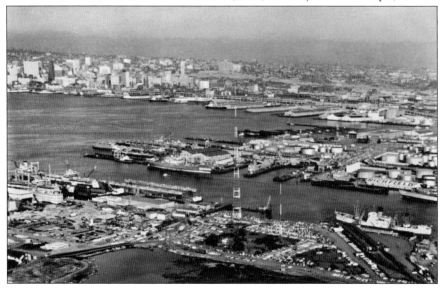

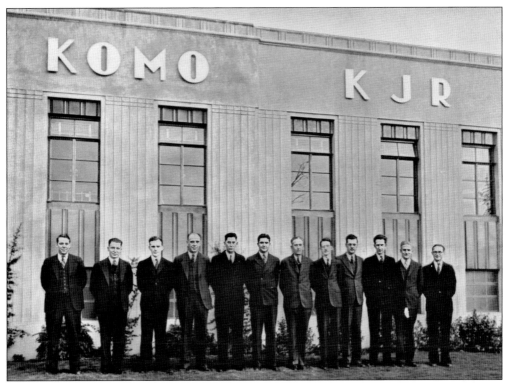

This was the KOMO-KJR transmitter staff at the West Waterway site at 2600 Twenty-sixth Avenue SW. Pictured from left to right are Lawrence "Whitey" White, Tommy Rewak, Fred Berry, Johnny Vinem, Ernie Rasmussen, Bob Smith, Francis S. Brott, an unidentified engineer, Bob Walker, Clarence Clark, Louis Greenway, and Harold Koontz. Brott, KOMO's chief engineer, built the original KOMO operating facility in 1926 and stayed with the stations for many years. (Courtesy of Homer Pope.)

This advertisement for the two Totem Broadcasters stations appeared in *Broadcasting Magazine* in 1941. As the local affiliates for both the NBC Red and Blue Networks, KOMO and KJR had a lock on most of the nation's best radio programming, so the stations attracted much valuable national advertising while the smaller Seattle stations survived mostly on local advertising. (Author's collection.)

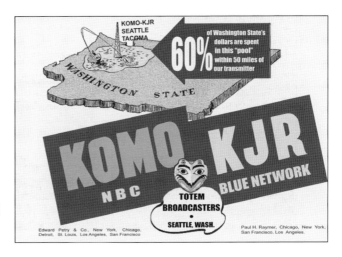

Merrill Mael began his radio career at KEVR and KOL in Seattle in 1939, moving up to KOMO-KJR and then on to NBC in Hollywood in 1941, where his resonant voice was heard on a number of network shows. After many years working in Alaska broadcasting, he returned to the Puget Sound area as a financial consultant. In retirement, he was regularly heard on Jim French's *Imagination Theater*. (Courtesy of Shirley and Christopher Mael.)

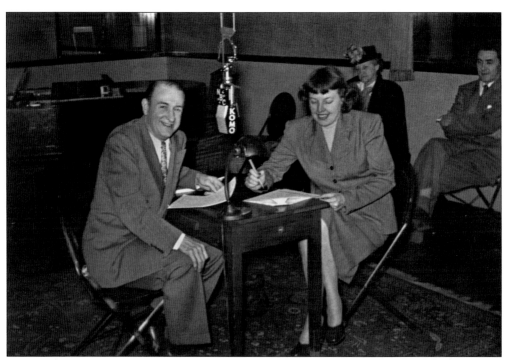

Here is KOMO's Grant Merrill interviewing Washington resident and author Betty MacDonald about 1945. MacDonald's first book, *The Egg and I*, was an instant hit and sold a million copies its first year. Merrill started in radio as a pianist on KJR in 1928 and rose to position of production director with the combined KOMO-KJR. In the 1950s, he was the public information director for the King County Red Cross. (Courtesy of Shirley and Christopher Mael.)

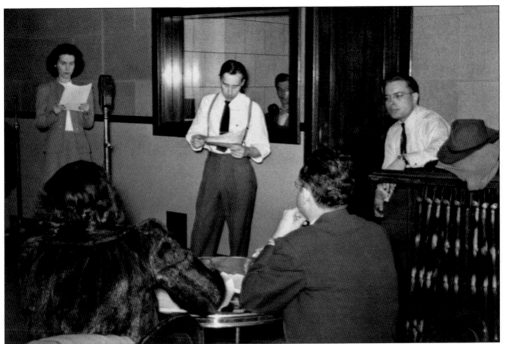

Although most of the programs heard on KOMO and KJR came from the NBC Red and Blue Networks, locally produced programs were an important part of the schedule. Here are two undated candid snapshots of KOMO broadcasts taken by Merrill Mael. Above is a production of the KOMO *Northwest Theater* with Al Morris, Bob Hurd, Lis Leonard, and Dale Smith. Producer Bob Hurd is also seen in an unidentified production below with radio actor Don Driver. Hurd operates the sound-effects turntable cart. Some of the local programs heard on KOMO, as described in a 1941 schedule, were *That Girl from Fishers, Mixem and Matchem, Jules Buffano's Dancer Answers, Industry and Defense, Nichols Radio Parade, The Fish Finder,* and *The Quiz of Two Cities,* which was also heard over KGW in Portland. (Both, courtesy of Shirley and Christopher Mael.)

Hugh Barrett Dobbs began his radio career in 1925 doing morning exercise programs over KPO in San Francisco. Within a few years, "Dobbsie" was hosting *Shell Ship of Joy* on the NBC Pacific Coast Network. When NBC cancelled the program in 1939, Dobbsie sailed his *Ship of Joy* program northward to KOMO, where it was heard mornings into the 1940s. Here, Captain Dobbsie swaps hints on knot tying with Seattle Sea Scout Warren Barde. (Author's collection.)

Morton Presting announces a program in the Skinner Building about 1941. Presting was later a supervisor for Far East programs for the Voice of America and was responsible for broadcasts to Korea during the Korean War. (Courtesy of Shirley and Christopher Mael.)

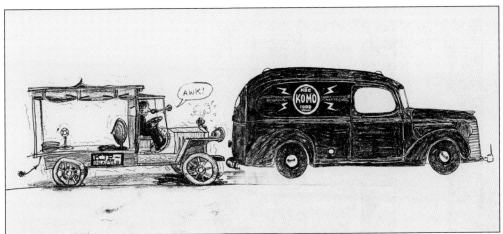

Although both stations were under common ownership, KJR was always the black sheep of the family. KOMO had the best programs, the best talent, and the biggest budget, and KJR was left with the hand-me-downs. When a new KOMO remote vehicle was being planned, an unidentified staff artist created this drawing, humorously indicating KJR's perceived second-class status within the Fisher organization. (Courtesy of Clay Freinwald.)

In 1945, the FCC's new duopoly rule prohibited the ownership of multiple stations in a single community, forcing KOMO and KJR to separate. This November 1945 ceremony marked the separation of the two stations. Birt Fisher became the 100 percent owner of KJR in a stock swap, with no money changing hands. Pictured from left to right are O.W. Fisher, president of KOMO; Marion Bush, his secretary; Jean Wylie, Birt Fisher's secretary; and Birt R. Fisher. (Courtesy of Homer Pope.)

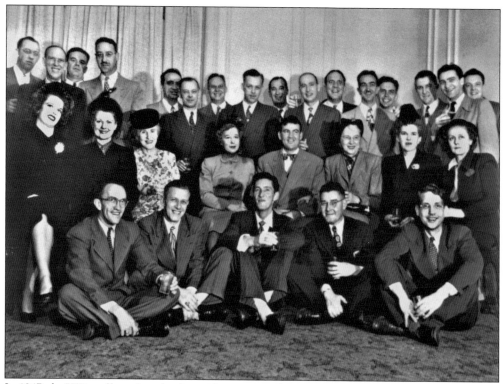

In 1947, the KJR staff numbered at least 29 persons, judging from this image taken at the company Christmas party. That year, Birt Fisher sold KJR to Marshall Field Enterprises for $700,000 and retired to his Ellensburg ranch. The new owner was Marshall Field III, whose holdings included KOIN AM/FM in Portland, WJJD in Chicago, and the *Chicago Sun Times* newspaper. (Courtesy of Homer Pope.)

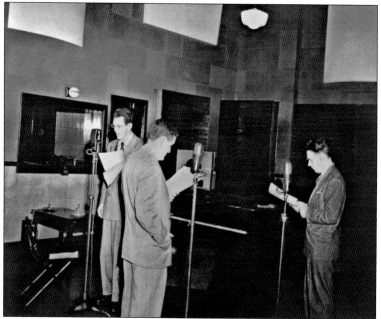

An unidentified KJR program broadcasts from the Skinner Building after the separation from KOMO. The two stations continued to share studio space at first, but plans were already under way for KOMO to move out of the Skinner Building into an elaborate new studio building of its own. (Courtesy of Homer Pope.)

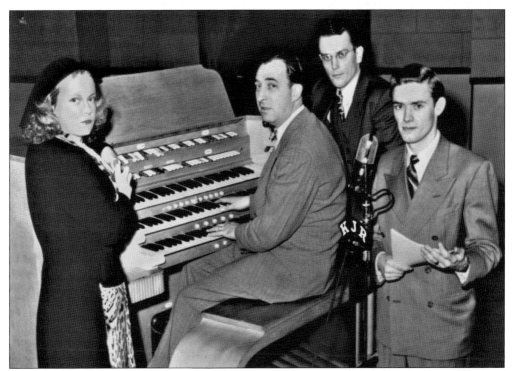

This was the cast of *Narratives at Nine*, a weekly quarter-hour program heard on KJR every Wednesday at 9:00 p.m., sponsored by the University District Commercial Club. From left to right are Marge McPherson, scriptwriter and coproducer; Eddie Clifford, organist; Dave Crockett, producer; and Jerry McCumber, narrator. McCumber was KJR's program director and a staff announcer. He also created *The Seattle Story*, a program in which he did eight or nine characterizations. (Courtesy of Homer Pope.)

Here are some of the popular voices and musicians heard on KJR during the late 1940s. From left to right are (seated) Tubby Clark and Martha Wright; (standing) Hal Sebenick, Eddie Clifford, Ivar Haglund, Bob Davies, and announcer Jerry McCumber. Clifford and Clark were a popular piano and organ duo heard for decades on Seattle radio. Haglund was a popular local folk singer and restaurateur. (Courtesy of the Museum of History and Industry.)

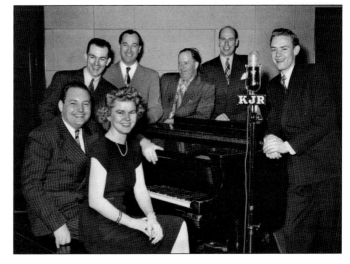

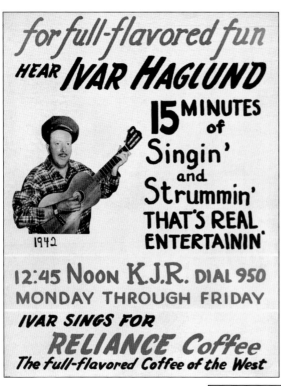

Ivar Haglund opened Seattle's first aquarium in 1938 and his first Acres of Clams restaurant in 1946. He was an expert on Northwest folk music and could sing more than 200 songs from memory. During the early 1930s, he worked hard at developing his image as a Western folk singer and became a champion of Northwest folk music. Haglund's radio career was launched by luck in 1940, when he answered an emergency call from interviewer Morrie Alhadeff to fill in for a guest who had canceled. Haglund went on the air and sang some of the shanties he had written and ascribed to the appropriate tanks in his aquarium. He soon became a regular featured singer on KJR, KIRO, and later on *The J.P. Patches Show* on KOMO-TV. (Both, courtesy of Ivar's Restaurants.)

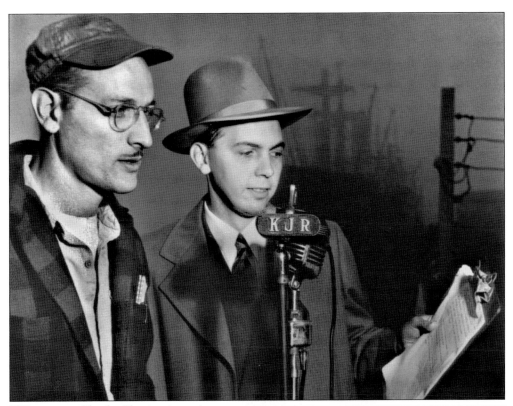

KJR reporter Charles Herring interviews Bryon Fish from the *Seattle Times* during the 1947 Salmon Derby. Herring grew up on his parents' wheat farm near Walla Walla, where he began his radio career at KUJ. After serving in the Navy during World War II, Herring worked for KJR as a staff announcer for five years. In 1951, he joined KING-TV and became Seattle's first television news reporter. (Courtesy of Homer Pope.)

Richard Donald "Dick" Keplinger, the dean of the Puget Sound area newscasters, came to Seattle in 1935. He was heard on KVI, KOMO, KJR, KIRO, and KXA Radio and later became a fixture on KOMO-TV. This photograph was taken in the early 1950s, when his daily KJR news reports were sponsored by Shell Oil. Keplinger retired in 1963 and died in 1965 at the age of 50. (Courtesy of Homer Pope.)

The Heidelberg Harmonaires performed on KJR for eight years beginning in 1949, sponsored by Heidelberg Brewing Co. Claude Raye (piano) and Scott O'Dare (vocal) were heard three to five nights a week on 31 radio stations in Washington, Oregon, Idaho, and Alaska. They signed off each program with "Your Tacoma neighbor, the Columbia Breweries." (Courtesy of Tacoma Public Library, CB7485-27A.)

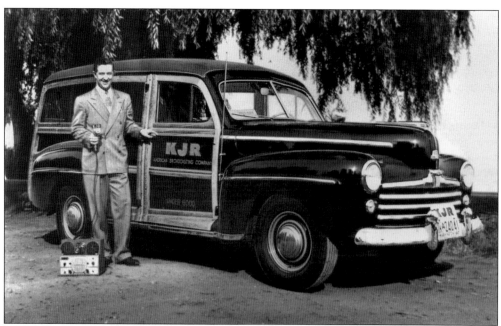

In this 1947 image, reporter Bob Ferris poses by a KJR news vehicle and an early Boosey & Hawkes wire recorder. The wire recorder was the first magnetic recording device available, preceding audiotape recording. Earlier versions of this British-made recorder were carried into battle by combat reporters in World War II. The news car is the iconic 1947 Ford Super Deluxe Woody wagon. (Courtesy of Homer Pope.)

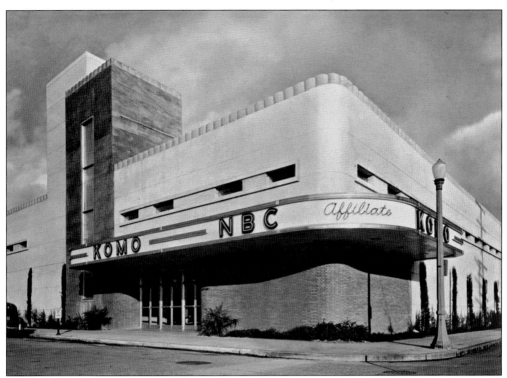

After four years of planning and construction, KOMO moved into this imposing three-story broadcast center at Fourth Avenue and Denny Way in early 1948. The $750,000 structure was built as a magnificent radio palace, but it was also planned to accommodate a future television station. In 1953, KOMO-TV went on the air from the building, and the combined radio-TV broadcast plant would stand for 40 years. (Courtesy of Jack Barnes.)

This view of the lobby and reception area shows artist E.T. Grigware's impressive mural *Across Horizons* that graced the building's entrance during the entire life of the building. The mirrored waiting room can be seen in the background. The glass doors to the left led to the operations center and onward to the studios. (Courtesy of Jack Barnes.)

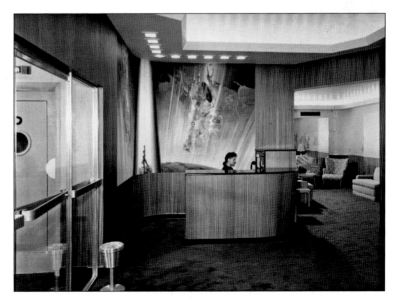

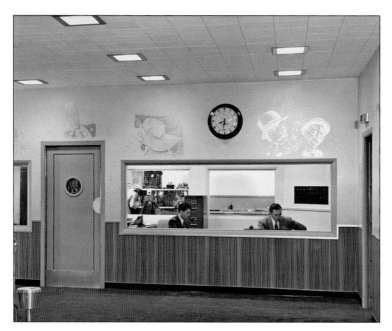

These glass windows offered a glimpse into the station's main operations center. Its occupants had a direct view into the master control room (front cover) and overlooked the entrances to all five studios on the main floor. In later years, this would become the KOMO newsroom. Caricatures of famous NBC performers and artists decorated the hallways. (Courtesy of Jack Barnes.)

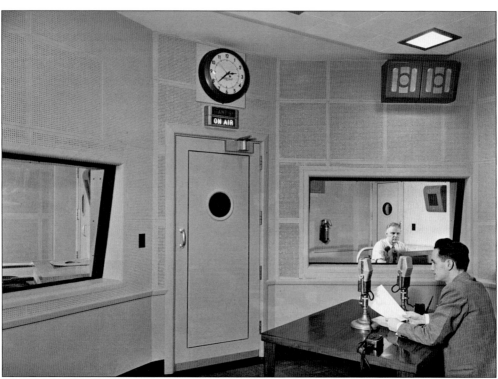

In announcer Studio E, the announcer has a view into either of its two shared control rooms. A mix of perforated acoustic tiles and plywood panels furnished just the right amount of acoustic ambience. The heavy isolated doors with their porthole windows were the classic 1940s studio doors. Jack Kerr is the operator seen through the window in this picture; the announcer is not identified. (Courtesy of Jack Barnes.)

In addition to the master control room, each studio had its own dedicated control room. The exceptions were the small announcer Studios E and F, which shared a single control room, seen here. There was also one control room for Studios D and E arranged so the two control rooms served three studios, and any combination of two could be on the air at the same time. The audio console and turntables are RCA products. (Courtesy of Jack Barnes.)

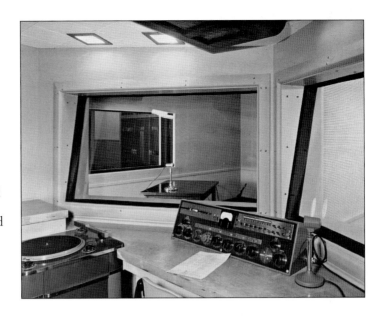

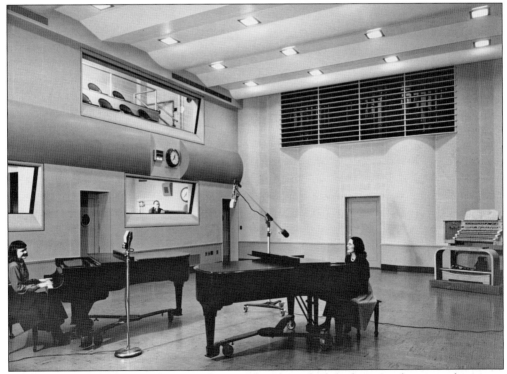

This view of Studio B shows the music director's booth on the left, the control room in the center, and the sponsor's booth above the control room. The plywood semicylindrical baffles were designed to evenly disperse acoustic reverberations. The floors floated on springs with felt isolators, and the ceiling was suspended from the building framework. The Wurlitzer organ, moved over from the Skinner Building, can also be seen here. (Courtesy of Jack Barnes.)

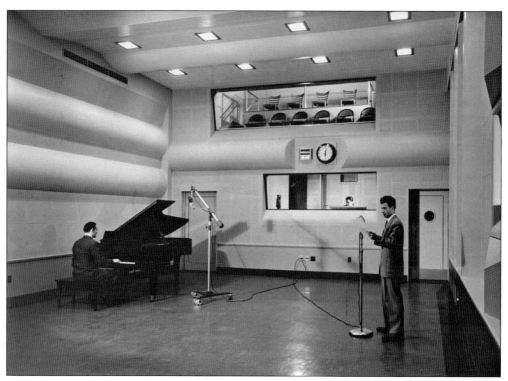

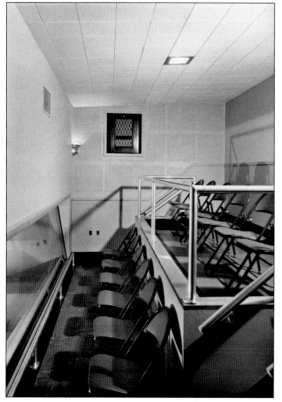

Studio C was slightly smaller but was still capable of holding a medium-sized music ensemble. A window on the right wall led to the music director's booth, which looked into both large studios. This was done so that complex programs could utilize both studios, with an orchestra in the larger studio and actors and announcers in the smaller studio. When KOMO-TV was built, both B and C became TV studios. (Courtesy of Jack Barnes.)

This is an inside view of one of the two sponsors' booths in the KOMO studio building. Both Studios B and C had these second-floor rooms so that VIPs could observe the live broadcast without disturbing the talent. This concept was originated by NBC and adopted by many other broadcasters. (Courtesy of Jack Barnes.)

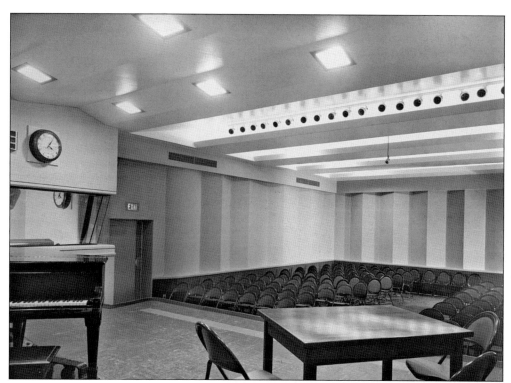

This large studio in the basement of the KOMO building featured a stage, plus seating for a large audience. The control room was arranged so that the operator had a view of both the stage and the audience. Theater lighting spotlights were mounted in a recessed region in the ceiling. In later years, this room was converted into an auxiliary TV studio and was then finally divided up into offices. (Courtesy of Jack Barnes.)

This 600-foot-tall tower was constructed on the north side of the KOMO studio building in 1949 for the new KOMO-FM antenna. It was also planned as the support for a KOMO-TV antenna, but Fisher Broadcasting did not obtain a TV license until 1953. When that happened, KOMO-FM was shut down because of financial losses, and the tower was moved to its present location on Queen Anne Hill for KOMO-TV. (Courtesy of the Museum of History and Industry.)

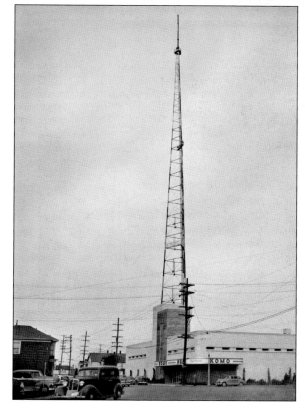

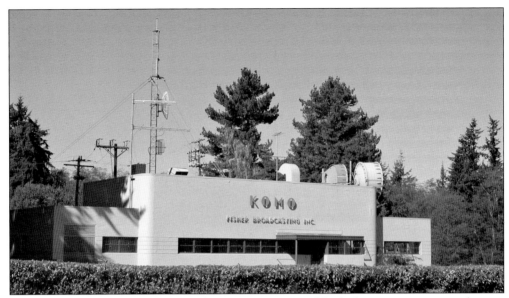

In 1948, KOMO achieved a long-sought power increase and built this new transmitter plant on Vashon Island. The new RCA BTA-50F transmitter was so large that the structure was literally built around the transmitter and had separate rooms to hold the ventilation fans and transformers. It was one of the first big postwar transmitters to be delivered by RCA. The three-tower directional antenna system occupied 77 acres of Vashon Island real estate. (Courtesy of Walt Jameson.)

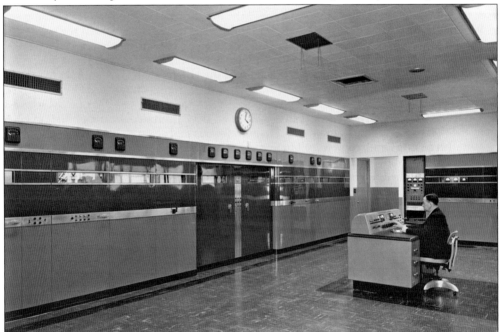

The impressive KOMO transmitter filled an entire wall in the Vashon Island building. The transmitter engineer's desk in the center of the room held the operator's console, giving him hands-on control of the main transmitter functions plus the program audio. To his far right was the antenna "phasor," which created the station's directional radiating pattern by controlling the amount of power fed to each of the three towers on the property. (Courtesy of Jack Barnes.)

Five

OTHER SEATTLE STATIONS
OF THE 1930S AND 1940S

Louis Wasmer was an important player in early Seattle radio. In 1921 and 1922, he built the transmitting equipment for KDZE, KZC, and his own station, KHQ. In 1925, he moved KHQ to Spokane, where he built it into an important network station and later controlled most of Spokane broadcasting. In 1928, he and his brother-in-law Archie Taft Sr. bought KFOA, changed the call sign to KOL, and moved it into the basement of the new Northern Life Insurance Building.

When Vincent Kraft took over KTCL from Burt Fisher in 1927, he changed the call letters to KXA and moved it to the Bigelow Building. KXA had an unlimited time license with 1,000 watts on a desirable frequency, while many other stations were required to share frequencies. That did not go unnoticed by Tacoma's KVI, which asked the Federal Radio Commission to swap its part-time 760 frequency for KXA's more desirable 570. The government decided for KVI in 1932, stating that Tacoma was entitled to its own part-time station, and moved KXA to 760, where it was limited to daytime to protect WJZ in New York. In 1934, Kraft sold a majority share of KXA to Ronald Meggee but kept a minority interest until it was sold again in 1946.

Not all of Seattle's stations were well-financed operations with network affiliations and quality programs. The big stations shared the dial with lower-power stations that were modestly financed and broadcast limited hours with programs of marginal quality. KRSC, KVL, and KPCB were Seattle's low-budget phonograph record stations. KRSC was a 100-watt daytime station in the Washington Athletic Club, started in 1926 by Palmer Leberman and Robert Priebe, who owned the station until 1949. KVL, built in 1927 by radio amateur and experimenter Arthur Dailey and later known as KEEN and then KEVR, broadcast with 100 watts, sharing time on 1370 kilohertz with KRKO in Everett. KTW, the First Presbyterian Church station, broadcast noncommercial religious programs only on Thursday nights and Sunday days.

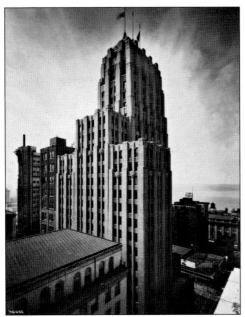

The Northern Life Tower, at the corner of Third Avenue and University Street, was the home of Seattle's KOL. In 1928, sporting-goods store operator Archie Taft Sr. purchased KFOA from Rhodes Brothers, changed the call letters to KOL, and moved the studios to the ground floor of this art deco masterpiece building. KOL became Seattle's first CBS affiliate in 1930. When CBS moved to KIRO in 1938, KOL changed to the Mutual-Don Lee Network. (Courtesy of Seattle Public Library.)

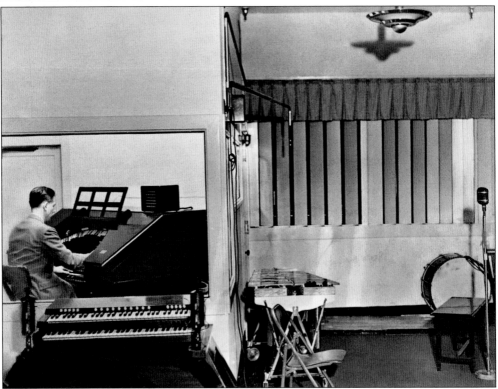

Don Isham, KOL's music director, plays the Kimball 3-manual 12-rank theater organ in KOL's Northern Life Tower studios. According to the Puget Sound Theater Organ Society, the organ, installed by Balcom and Vaughan in 1931, was a combination of a Kimball from the Grand Theatre and a Wurlitzer from the Colonial Theatre. It was controlled by a Wurlitzer console modified by Balcom to 3 manuals. (Courtesy of Puget Sound Theater Organ Society.)

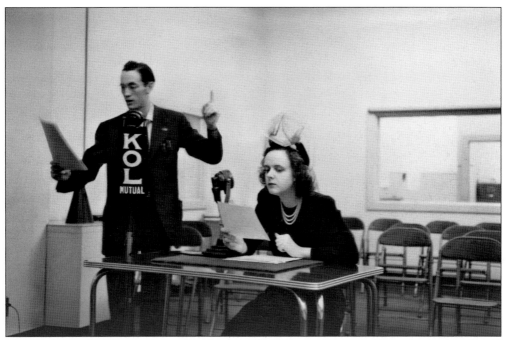

KOL had a single large studio in the Northern Life Tower, plus a small announcer booth and a control room. Merrill Mael is pictured on the air with Amy Bowden from the large studio in about 1940. Among the many radio voices that graced this studio was announcer Wendell Niles, who joined KOL in 1930, then moved on to NBC in Hollywood in 1935, and later became one of network radio and TV's great announcers. (Courtesy of Shirley and Christopher Mael.)

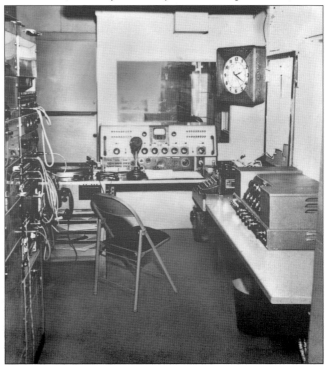

This is a view of the KOL control room in the 1940s. The main RCA console is flanked by a smaller Western Electric mixer to the right. The large Western Union studio clock was found at most radio stations until the 1960s. Western Union leased the clocks for $25 a year, which included a telegraph line that synchronized it with the Naval Observatory clock in Washington at the top of every hour. (Courtesy of Museum of History and Industry.)

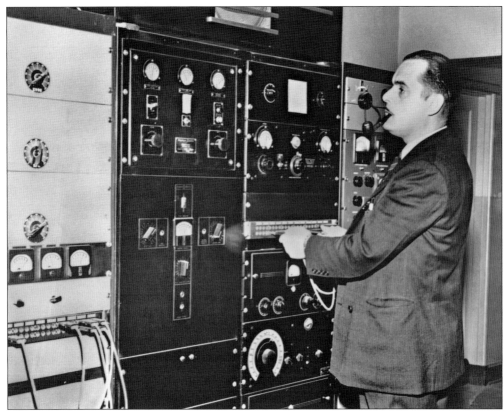

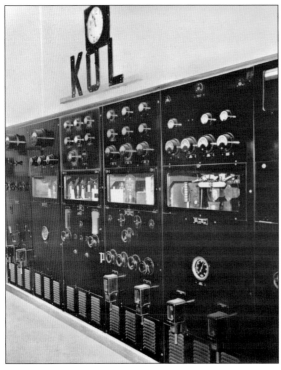

Engineer/announcer Earl Thoms is shown adjusting KOL's monitoring equipment at the Harbor Island transmitter site in the late 1930s. Thoms started his career at KGY in Olympia, which was also owned by Archie Taft, and moved to KOL three years later. After his wartime service, he returned to Seattle and worked for KXA for many years. (Courtesy of Museum of History and Industry.)

KOL (originally KDZE and KFOA) first broadcast from the twin towers atop the Rhodes Department Store building. In 1934, a new KOL transmitter site was built on the new vacant landfill area called Harbor Island. There, KOL was the first Seattle station to use a vertical tower instead of a horizontal T antenna. This 5,000-watt Western Electric water-cooled transmitter dates back to that era. (Courtesy of Museum of History and Industry.)

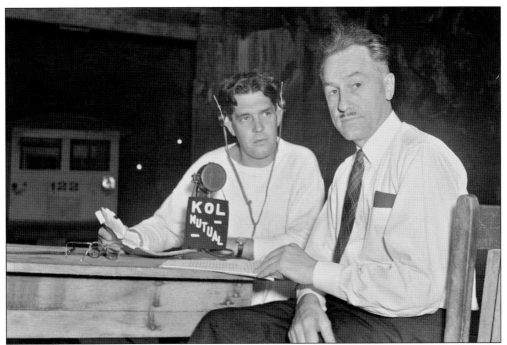

KOL announcer Dudley Williamson interviews Seattle City Light superintendent Eugene R. Hoffman at the Skagit River Hydroelectric project headquarters at Newhalem on August 19, 1939. The occasion was a live, coast-to-coast broadcast called *The Romance of Power*. The half-hour Mutual program dramatized the generation of hydroelectric power in Washington State. The broadcast was a memorial to Seattle City Light superintendent James Delmage "J.D." Ross (1872–1939), who died a few months earlier. (Courtesy of Seattle Municipal Archives.)

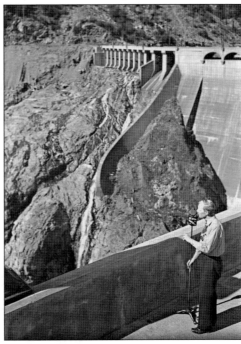

KOL announcer Wheeler Smith is seen at the top of the Diablo Dam on the Skagit River, while Frank Anderson was 310 feet below at the bottom of the spillway. Each man held a microphone so that listeners could hear the roar of the water flowing over the spillway. All communication was via wires strung between the announcers, and the link with Seattle was by wire as well. (Courtesy of the Seattle Municipal Archives.)

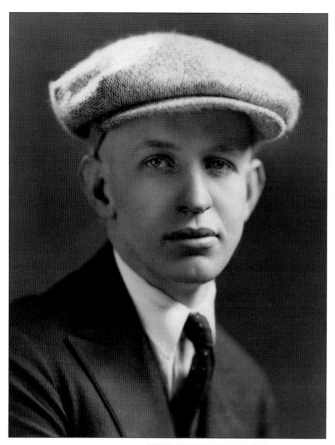

Leo Lassen was a sportswriter who began doing Seattle Indians baseball re-creations for KXA in 1931. He would sit in an empty studio and describe an away game, embellishing on bare statistics received by telegraph from the ballpark. After Emil Sick bought the Pacific Coast League team in 1938 and renamed it the Rainiers, Lassen broadcast the games live on KJR and other stations until 1960. He was inducted into the Washington Sports Hall of Fame in 1974. (Courtesy Museum of History and Industry.)

Howard Duff was born in Bremerton and grew up in Seattle. He started as an actor on KOL, and then he became a staff announcer at KOMO. In 1937, he moved to KFRC in San Francisco and then to Hollywood the following year. He starred in the CBS detective series *The Adventures of Sam Spade* from 1946 to 1950 but was fired when his name was published in *Red Channels*, an anti-Communist tract. He later played many TV and motion pictures roles. (Author's collection.)

KVL was a small phonograph record station established in 1927 by Arthur Dailey, a ham radio operator and experimenter. It broadcast with 100 watts on 1370 kilohertz, sharing time with KRKO in Everett. The KVL studio was in the Smith Tower, and the antenna was a long wire stretching to an adjacent building. Here, Dailey tries out a two-way shortwave transmitter from the trunk of his 1938 Hudson Terraplane. (Courtesy of Museum of History and Industry.)

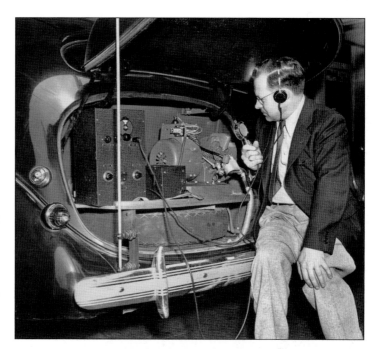

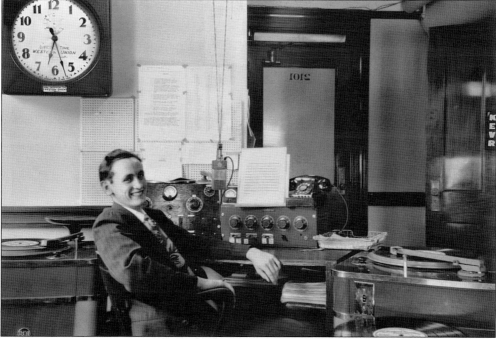

This is announcer Merrill Mael working his first radio job at KEVR in the Smith Tower in 1939. In the mid-1930s, Arthur Dailey's KVL became KEEN and then KEVR. In 1935, Dailey won a suit against Washington State, charging that the collection of state sales taxes from broadcasters interfered with interstate commerce. Washington broadcasters have been exempt from sales tax ever since. Dailey sold KEVR in 1939 to Elroy McCaw and other investors. (Courtesy of Shirley and Christopher Mael.)

When Vincent Kraft took over KTCL and changed it to KXA, he moved the station into the Bigelow Building, where it would remain until 1953. Built in 1923, the building was prominently located on the corner of Fourth and Pike Streets. Its entrance is visible in this 1939 photograph, just south of the Colonial Theater. The Bigelow Building was demolished in 1984. (Courtesy of the Seattle Municipal Archives.)

Earl Reilly was a young announcer hired by KXA during World War II. KXA signed off at local sunset to protect New York's WJZ, also on 770 kilohertz, but came back on the air when WJZ was silent overnights. This 10:00 p.m.–3:00 a.m. air shift was the home of *Stay-Up Stan, the All Night Record Man*, Seattle's only late-night radio program. Jim Neidigh was KXA's original "Stay-Up Stan," but Reilly also held the job until moving to daytime hours. (Courtesy of Earl Reilly.)

John Dubuque started in radio at KTW in 1938 and then was KXA's chief engineer from 1940 to 1970. He doubled as an announcer during the 1940s, finally ending up as station manager at the end of his tenure. Here is John on the air at the KXA console in the Bigelow Building around 1942. (Courtesy of Chris Dubuque.)

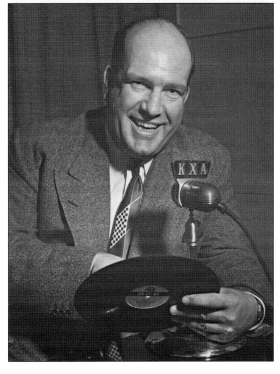

Bob Nichols, also known as "The Record Man," ran a record store in the triangular Bartell Drugs building, across the street from the Bigelow Building. His recorded music program was heard on KXA in the afternoons in 1948. He broadcast some of his programs from the Triangle Building and others from KXA's Bigelow Studio. (Courtesy of Chris Dubuque.)

Spike Hogan's FRIENDLY TRAIL GANG

K X A
770 KC
SEATTLE, WASHINGTON

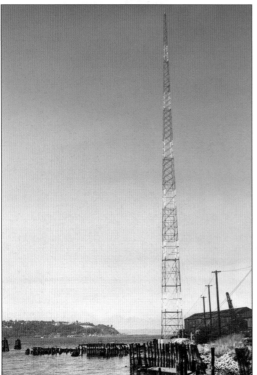

When a dentist bought a half-hour country and western music program in the middle of Earl Reilly's afternoon shift, he created the fictitious "Spike Hogan" to host the program. It became an instant hit, and he inducted other staffers to become members of the group he called the "Friendly Trail Gang." Spike is pictured at the center top, with, from left to right, "Cowboy Pinkeye" (Al Bowles), "Clem Clump" (Len Beardsley), "Cowboy Shorta" (John Dubuque), and "Slim" (Bob McCoy). (Courtesy of Earl Reilly.)

In 1940, KXA built this tower at Pier 36, which soon became the Seattle Army Port of Embarkation. In 1941, Army dredging undermined the footings, and the tower began to lean. KXA made emergency arrangements to move to the old KFOA Rhodes building antenna, recently vacated by KIRO. This "temporary" antenna was used for the next 42 years. The waterfront tower was dismantled and later supported the channel 9 TV antenna at Broadway High School. (Courtesy of Chris Dubuque.)

KXA's secondary studio was in the Pier 36 building, next to the home-built 1,000-watt transmitter. The *Stay-Up Stan* late night broadcasts originated from this location. Because KXA was the only station in the West using the 770 frequency at the time, music requests poured in from around the country. That ended when KXA lost its waterfront tower and other stations moved onto the channel. (Courtesy of Chris Dubuque.)

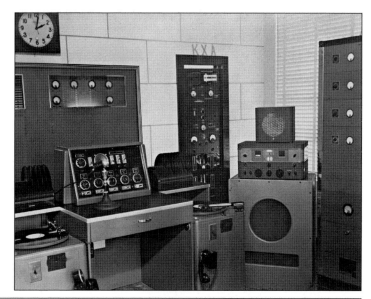

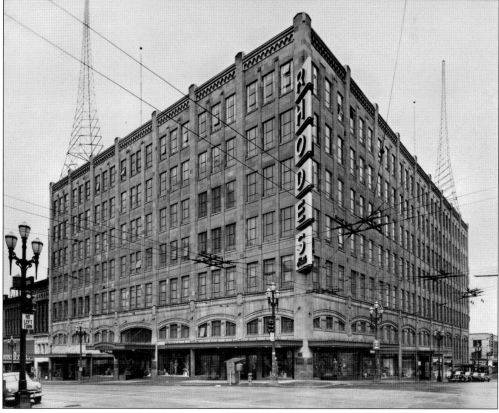

This antenna on the roof of the Rhodes Department Store was used by KXA for 42 years. It was built in early 1920s for KFOA (KOL), and then KPCB (KIRO) used it from 1936 to 1941. The Rhodes building was occupied by the J.C. Penney Co. in the 1950s and was demolished in 2003 to make way for the Seattle Art Museum and Washington Mutual Tower. (Courtesy of the University of Washington Special Collections, UW33481.)

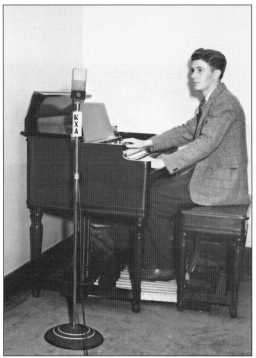

In June 1946, KXA staff members traveled to San Francisco via Naval Air Transport Service to conduct interviews for the Sunday public-service program *Your Navy Reports.* From left to right are John Dubuque, KXA engineer; Scott Siefert, KXA special events director; Florence Wallace, KXA manager; Lt. Cdr. H.L. Smith, pilot; and Lt. (jg) C.F. Imhoff. Wallace, who started her radio career with KJR in 1926, was KXA's manager until 1946. (Author's collection.)

Any radio station worth its salt in the 1930s and 1940s had both a piano and organ in the studio. This was KXA's organ on the third floor of the Bigelow Building. Mike McMullen (pictured), KXA's chief engineer before John Dubuque, also built the Pier 36 transmitter. (Courtesy of Chris Dubuque.)

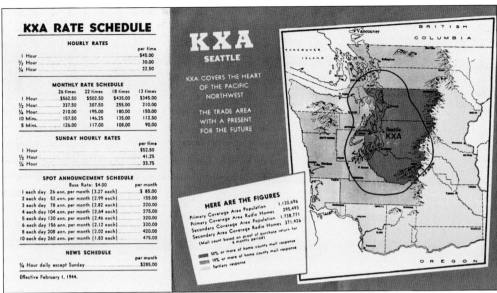

This 1944 KXA rate card shows the station's coverage area and advertising rates. The reverse side promoted the station's prime dial location, sandwiched between KIRO (CBS), KOMO (NBC Red), and KJR (NBC Blue). KXA claimed that "80% to 85% of all radio listening in Seattle, according to all surveys, is done between 710 on your radio dial and 1000," and "switching back and forth, the listener can always find the music he wants at 770 KXA." (Courtesy of Chris Dubuque.)

In the 1930s, Freeman "Tubby" Clark and Eddie Clifford headed the house band at the Show Box Cabaret on First Avenue, backing artists such as Jimmy Durante, Sophie Tucker, and Ted Lewis. Their *Clifford & Clark* piano-organ radio programs began at KIRO and were heard continually on Seattle radio for 30 years. Clifford died in 1967, and Clark continued as a solo act into the mid-1970s. He died in 1982. (Author's collection.)

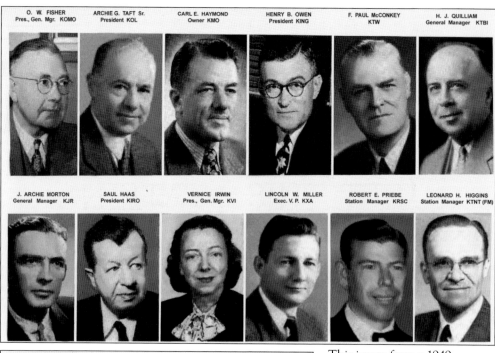

O. W. FISHER
Pres., Gen. Mgr. KOMO

ARCHIE G. TAFT Sr.
President KOL

CARL E. HAYMOND
Owner KMO

HENRY B. OWEN
President KING

F. PAUL McCONKEY
KTW

H. J. QUILLIAM
General Manager KTBI

J. ARCHIE MORTON
General Manager KJR

SAUL HAAS
President KIRO

VERNICE IRWIN
Pres., Gen. Mgr. KVI

LINCOLN W. MILLER
Exec. V. P. KXA

ROBERT E. PRIEBE
Station Manager KRSC

LEONARD H. HIGGINS
Station Manager KTNT (FM)

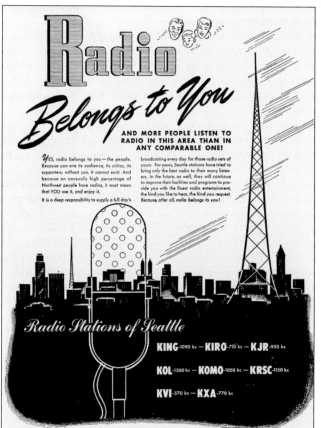

This image from a 1949 Seattle special supplement in *Broadcasting Magazine* shows the managers of all of Seattle's radio stations. Some of the people seen here, such as Saul Haas, Carl Haymond, Archie Taft, and H.J. "Tubby" Quilliam, had a profound influence on the structure and character of Puget Sound radio. (Author's collection.)

In 1948, television was the new threat to the radio business. Seattle's first TV station, KRSC-TV, went on the air Thanksgiving Day of that year. In an unusual show of cooperation among radio competitors, seven Seattle area stations joined to place this full-page local newspaper ad to remind people that radio was not going away. The unspoken message was probably, "Advertisers, please don't forget us!" (Courtesy of seatacmedia.com.)

Six

"IF YOU CAN'T GET THIS STATION, BETTER GIVE UP"

The Pacific Coast Biscuit Company was a competitor to Fisher Flouring Mills Co., with several mills located around the West. Moritz M. Thomsen, the owner of the Pacific Coast Biscuit Company, felt he had to match his competitor's radio efforts, so he started the Queen City Broadcasting Company. His station, KPCB, went on the air on April 1, 1927, from a tiny studio in the Central Building and with a 50-watt transmitter in the Pacific Biscuit Building at 4100 East Marginal Way. KPCB increased its power to 100 watts later that year, sharing a frequency with KPQ until that station moved to Wenatchee. The KPCB transmitter moved to the roof of the Rhodes building when KOL vacated the old Rhodes antenna.

But, unlike the Fishers, Thomsen never spent the money to turn KPCB into a serious station, and it was always the butt of local jokes for its lack of money to buy equipment or replacement parts. For example, for remote broadcasts, the station's only microphone would be rushed to the remote location by taxi while phonograph records were played to cover the airtime.

In 1935, Moritz Thomsen's son had a legal run-in with Saul Haas, the director of the US Customs Office in Seattle and a former Democratic Party campaign organizer. Haas received shares of KPCB stock as a settlement, which sparked his interest in the radio business. Soon, he led a group of businessmen to purchase the remaining shares and changed the call letters to KIRO.

The next year, flexing his political muscles, Haas gained approval to increased KIRO's power to 1,000 watts and move the frequency to the more desirable 710 kilohertz. He also lured the lucrative CBS network affiliation away from KVI and KOL. In 1941, he obtained approval to increase KIRO's power to 50 kilowatts, creating the Northwest's first maximum-power station.

During the 1940s, KIRO and CBS were the Puget Sound region's major source of important war news. Haas instructed his staff to make daily recordings of all CBS news broadcasts for delayed rebroadcast. This collection of KIRO acetate discs, now in the National Archives, is the largest collection of war news recordings extant today.

The Pacific Coast Biscuit Company was a competitor to Fisher Flouring Mills Co., with several locations around the West. The company's unfortunate choice of trademark was a swastika, but this was quickly abandoned at the start of World War II. The company started KPCB in April 1927, just four months after the Fisher station KOMO began broadcasting, but never invested to match the quality of the Fisher station. (Author's collection.)

Revered NBC news anchorman Chet Huntley started his career at KPCB in Seattle. The 24-year-old University of Washington student walked into the first radio station he could find and applied for a job. A few minutes later, Huntley was the new KPCB program director. "I ran sort of an underground news broadcast—I bought the newspaper from the corner and rewrote it," he later said. "I also ran the transmitter, spun records, wrote ad copy, and swept out." (Author's collection.)

Saul Haas bought KPCB in 1935 and changed the call letters to KIRO. His ample political influence was put to use in convincing the FCC to grant a power increase to 50 kilowatts in 1941. Engineer James B. Hatfield (left), seen here with Haas, was the technical force behind the new plant on Vashon Island. Together, Haas and Hatfield turned KIRO into the most powerful and influential station in the Northwest. (Courtesy of Jim Hatfield.)

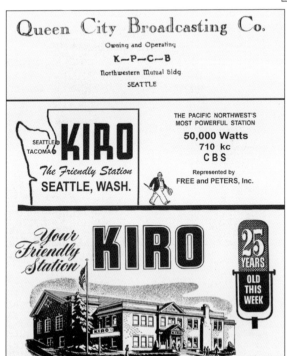

These graphics show KIRO at three different stages over the nearly 30 years that Saul Haas owned KIRO. The 1935 KPCB letterhead is from the FCC archives, the 1945 ad is from *Broadcasting Magazine*, and the 1952 silver anniversary ad is from the *Seattle Times*. Haas sold KIRO to Bonneville Broadcasting Co. in January 1964. (Author's collection.)

Postal Telegraph
THE INTERNATIONAL SYSTEM

CB465 30 DL XU

K SEATTLE WASHN 7 133P

H L PETTY

FEDERAL COMMUNICATIONS COMMISSION WASHN DC

AUTHORIZATION IS ASKED TO TEST NEW EQUIPMENT AND CONDUCT PROGRAM

TESTS ON 710 KILOCYCLES UNDER OUR SPECIAL AUTHORIZATION RATHER THAN ON

650 AS OUR LICENSE REQUIRES

QUEEN CITY BROADCASTING CO.

MAY 8 - 1935
FEDERAL COMMUNICATIONS COMMISSION

KPCB only operated during daytime hours to protect a Nashville station on 650 kilohertz. But, Haas's influence helped him achieve a change of frequency to 710 kilohertz with unlimited hours and increased power. An official move to the new channel was not allowed under the rules, so the station operated on an experimental authorization, which it renewed every three months over several years. (National Archives.)

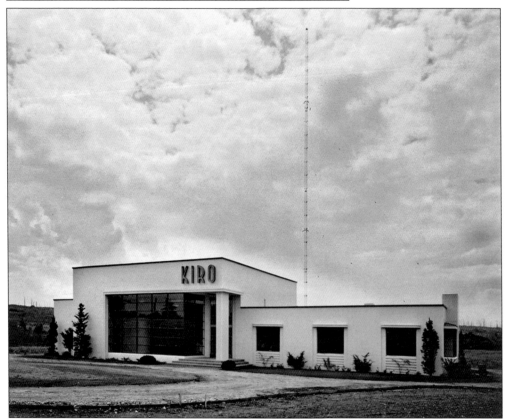

Here is the KIRO transmitter building on Maury Island shortly after its completion in 1941. The building won an architectural award that year. KIRO was the first maximum-power station in the Northwest and only the fourth west of the Mississippi. It also had the Northwest's first directional antenna system. Using two towers instead of one, KIRO reduced its nighttime signal towards the east to protect the Nashville station. (*Seattle Post-Intelligencer* photograph.)

KIRO chief engineer James B. Hatfield is shown at the controls of the new transmitter. Two soldiers from the 41st Army Infantry Division stand guard over the facility. The division, composed of National Guard units from Northwest states, was deployed in 1941 to defend the Washington and Oregon coastline against a possible Japanese invasion. The new KIRO plant was considered a critical wartime communications facility. (Courtesy of Hatfield and Dawson.)

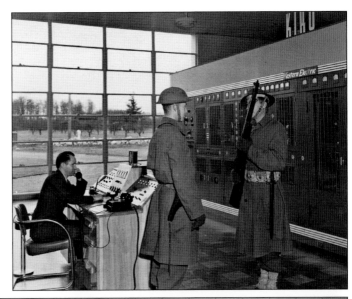

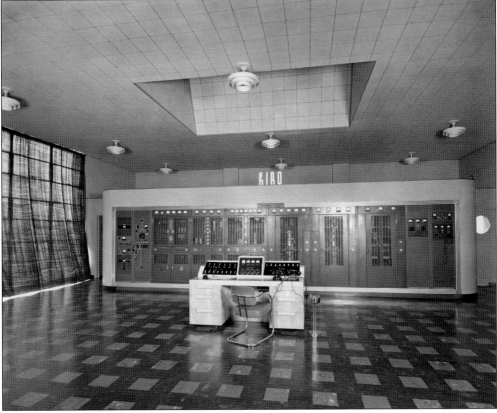

According to an FCC filing, this new Western Electric 407-A4 transmitter was supplied by Graybar Electric for $51,000, and 37 acres of Maury Island property was purchased at a cost $5,821. It had been clear-cut 30 years before, but 600 old-growth stumps remained and had to be removed by blasting. The towers and ground system cost $32,400, and the building was $23,100. The total cost of the new facility was $182,500. (Courtesy of Hatfield and Dawson.)

KIRO chief engineer James B. Hatfield shows one of the water-cooled tubes in KIRO's new transmitter to Doris Klemkaski (standing), the University of Washington "Queen of Queens," and Warner Bros. starlet Ella Raines. The ladies were among the celebrities on hand for KIRO's dedicatory broadcast on June 29, 1941. The transmitter used two of these giant tubes, which cost about $1,600 each in 1940. (Courtesy of Hatfield and Dawson.)

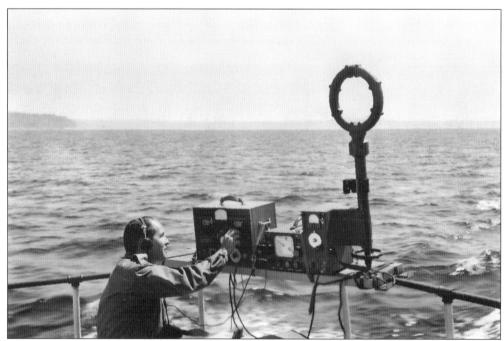

AM directional antennas require field proof-of-performance measurements, and KIRO engineers spent many months traversing the coverage area to measure signal levels. This was complicated because many of the required measurement points were in open water. Here, James B. Hatfield makes signal strength measurements from a boat in the Puget Sound. (Courtesy of Jim Hatfield.)

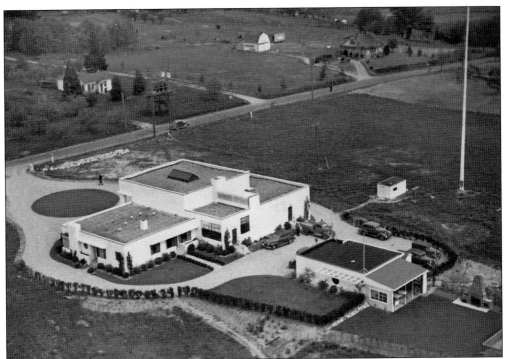

This 1944 aerial view shows the completed KIRO transmitter building complex on Maury Island. The main transmitter building included living quarters (at left) for the engineers who manned the transmitter 24 hours a day. A garage and shop is at lower right. The white mast at far right was an emergency antenna, installed at the request of the Army Air Force in case the main towers were bombed. (Courtesy of Jim Hatfield.)

The patio behind the garage was often used for company parties. Here are some KIRO employees celebrating the station's 15th anniversary on October 15, 1942. Among those pictured are James Hatfield (chief engineer), Maury Rider (chief announcer), Bill Moshier (farm editor), Loren Stone (station manager), Tubby Quilliam (general manager), and Len Beardsley (announcer). (Courtesy of Jim Hatfield.)

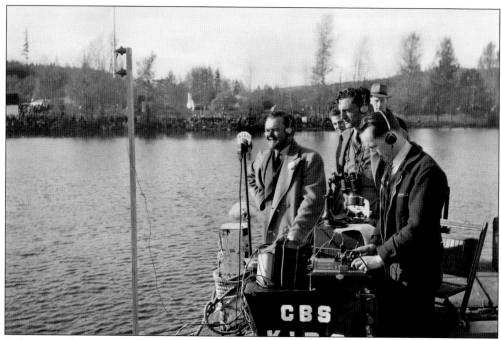

Before major-league sports came to Seattle in the late 1960s, the University of Washington rowing team was big news. The rowing team dominated the Pacific Coast, and in 1936 its eight-oar rowing scull won a gold medal in the Berlin Olympics. Afterwards, local interest was so high that KIRO would broadcast the local races live. The announcers here are on the air live via a shortwave link from the ship canal. (Courtesy of Jim Hatfield.)

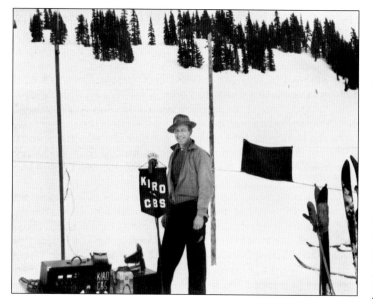

James Hatfield has the equipment set up for live broadcasts of the Silver Ski races from Mount Rainier. The annual race began at 10,000 feet at Camp Muir and dropped 4,600 feet over unkempt terrain, with the skiers racing side by side. The races were held from the early 1930s to 1948, ultimately ending due to several tragic accidents and the difficulty of staging a high-altitude race in unpredictable weather. (Courtesy of Jim Hatfield.)

Seven

SEATTLE RADIO FROM THE 1950S TO THE 1970S

As the field of radio continued to grow and mature, others also used their money and influence to create their own broadcasting empires. One of these people was Dorothy Stimson Bullitt, the daughter of Seattle lumber magnate C.D. Stimson and widow of attorney and politician Scott Bullitt. In 1947, deciding to enter the broadcasting field, Bullitt purchased KEVR in the Smith Tower Building. She changed the call sign to KING, hired a more professional staff, brought in better programming, and built a new 50,000-watt transmitter plant on Maury Island, down the road from KIRO. Soon there was an FM station—KING FM, one of the first the Northwest—and in 1949 she purchased Seattle's first TV station, KRSC-TV, which became KING-TV. KING AM was popular during the 1950s and 1960s, featuring NBC radio programs and middle-of-the-road music hosted by personalities like Al Cummings, Frosty Fowler, and Pat Lewis and sportscaster Rod Belcher. The "KINGsmen" broadcast from the "Ape Cage" glass studio facing Aurora Avenue during the 1950s and from a studio on the grounds of the 1962 World's Fair, and then Fowler did a morning show from a studio atop the Space Needle after the fair closed.

Seattle radio went through many changes in the 1950s and 1960s, adapting to changes in listener habits and new competition from television. KVI, KOMO, and KIRO were important stations during these decades. Familiar Seattle radio voices included Harry Long, Robert E. Lee Hardwick, Jim French, and Bill Yeend. French broadcast mornings from the Space Needle for several years after KING vacated in 1966. In 1964, Saul Haas sold KIRO to the Bonneville International Corporation, owned by the Church of Jesus Christ of Latter Day Saints. KIRO's new managers were Lloyd Cooney and Ken Hatch. The KIRO radio and TV stations moved into their new Broadcast House at Third and Broad Streets in 1968.

Other Seattle stations saw many changes during these decades. KRSC became Country KAYO. KXA was known for its respectful mix of classical music and news. KTW was a daytime station, still operated by the Presbyterian Church, programming adult music and religious programs. It shared its 1250 frequency with KWSU in Pullman, which had use of the frequency each evening until 11:15 p.m. The church sold the station in 1964, along with a new FM allocation, and it became a Top 40 station. KTW went through several format and ownership changes through the next several years and became KYAC in 1975. KTW-FM is now KZOK, and KTW-AM is KKDZ, Radio Disney.

KRAB went on the air in 1962 as a noncommercial, free-form community radio station, run mostly by volunteers. Licensed to the Jack Straw Memorial Foundation and modeled after the Pacifica Foundation stations in California, it was the creation of California broadcaster Lorenzo Milam. It was the first of 14 similar radio stations Milam would establish around the country in the 1960s and 1970s. KRAB began broadcasting from a former donut shop on Roosevelt Way. It was always short of money, its most prized asset being its 107.7-megahertz commercial frequency. Finally, the valuable KRAB channel was sold in 1984, and the station was reborn the next year as KSER in Lynwood.

Dorothy Stimson Bullitt owned several commercial office buildings and had applied for a new AM station. She told a reporter, "A friend who was also a tenant in the building came to me and said, 'Oh, don't bring in another station. There is already one too many, and that is mine. I'll sell you that if you want it, it doesn't have any listeners.' " So, in 1947, she purchased KEVR for $190,000. (Author's collection.)

Bullitt wanted the call letters KING for her new station, but they were already assigned to a merchant ship. A phone call to the owner revealed it was about to be decommissioned, and he agreed to give up the letters in exchange for a donation to his church. She then asked her friend Walt Disney to design a logo. He personally designed "KING Mike" for her in 1947, charging the princely sum of $75. (Author's collection.)

These three letterheads show the transformation of KING's image under Dorothy Bullitt's ownership. At the top is the KEVR letterhead when she bought the station in 1947. The middle version is from 1949, after the call sign was changed to KING and the Disney "KING Mike" logo adopted, before the 50,000-watt power increase. The third is from 1958, when KING was the NBC affiliate for both radio and television. (Author's collection.)

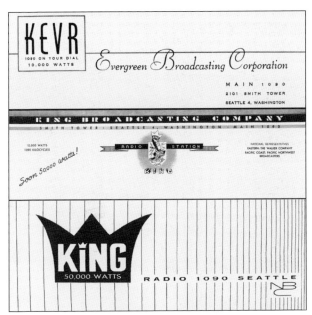

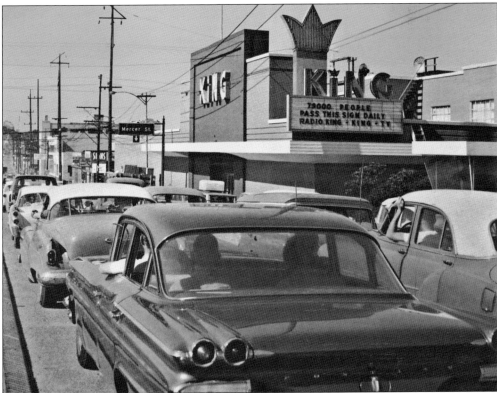

KING said that 79,000 vehicles each day passed by this reader board atop the KING Radio and Television Center at 320 Aurora Avenue North, which then, as US Highway 99, was the main northern route out of the downtown area. KING used the sign to promote its stations and sponsors. KING bought the former Baron's furniture store in 1951 and has occupied it for more than 50 years. (Photograph from a KING brochure.)

Frosty Fowler joined KING Radio in February 1958, hosting the overnight *Night Owl* program, and within a year he was one of the city's top morning DJs. From 1964 to 1966, he did his morning *KING Clock* shows from a studio atop the Space Needle. Known as "Fearless Frosty" for his on-air stunts, he is pictured climbing up the spire atop the Space Needle to hoist the WSU banner. (Courtesy of Frosty Fowler.)

Another of Fowler's stunts involved doing a live broadcast from the Space Needle painting scaffold during a 90-minute ride up to the observation deck. Other exploits included three parachute dives (one of which landed him into high-voltage power lines); hanging on a bosun's chair transiting between two Navy destroyers; hydroplane, stock car, and dogsled racing; and taunting rodeo bulls from the inside of a bull barrel. (Courtesy of Frosty Fowler.)

Frosty Fowler interviews hydroplane racer Ron Musson in the KING studio on top of the Space Needle in 1964. Musson, the driver of the *Miss Bardahl* hydroplane boat, won the World's Championship Seafair Trophy on Lake Washington in 1962 and would go on to win 10 more unlimited hydroplane races with his famous craft over the next four years before dying in a tragic accident on the Potomac River in 1966. (Courtesy of Frosty Fowler.)

Fowler suffered a head-on auto collision one Saturday morning in 1963 on his way to emcee a dog show in Tacoma and ended up in the hospital for several weeks with a broken hip. The young comedian Bill Cosby, costar of the popular TV series *I Spy*, was hired to do the morning show until Fowler could return. In this photograph, Cosby visits Fowler at Swedish Hospital. (Courtesy of Frosty Fowler.)

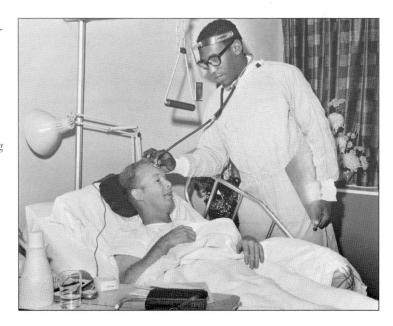

Al Cummings had three runs behind the KING microphone. He was first heard from 1951 to 1954, shortly after coming to Seattle, and then again from 1955 to 1956. In this 1964 photograph, he has rejoined the station for the third time, following Frosty Fowler from 10:00 a.m. to noon and then heard again after Ray Court from 3:00 p.m. to 5:00 p.m. Here, Cummings attempts to steal a birthday cake delivered to Frosty at the station. (Courtesy of Frosty Fowler.)

This is DJ Pat Lewis in the KING radio control room in 1963. Lewis joined KING in 1958, hosting the *Open House* program, 11:00 a.m. to 3:00 p.m. daily. Some of the other "KINGsmen" in those years were Ray Briem, Ray Court, Frosty Fowler, Al Cummings, Bill Terry, Buzz Lawrence, Dick Guthrie, Mark Wayne, and Bob Concie. (Courtesy of the Museum of History and Industry.)

During the Century 21 Exposition, also known as the Seattle World's Fair, KING broadcast its entire program schedule—seven days a week, day and night—from this studio in the Coliseum building. Here, Ray Court broadcasts from the "World's Fair Central" studio in 1962. KING also broadcast 14 "World's Fair Open Mike" remotes daily from roving reporters around the fairgrounds. (Courtesy of Earl Reilly.)

"Oh, why do they call it the *Sunrise Club?*" KVI's 1950's early-morning personality Harry Long needs another cup of coffee in this publicity shot in the Camlin Hotel studios. Long was the morning man and program director at the Seattle AM radio station KVI in the 1940s and 1950s. His "radio feud" with the station's western music host Buck Ritchey went on for 20 years. (Author's collection.)

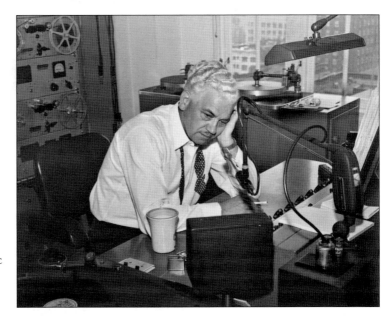

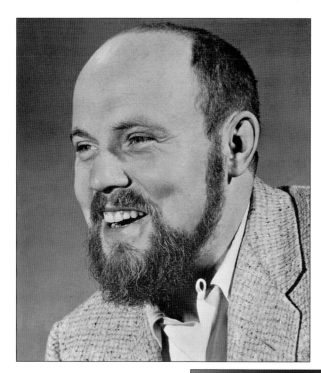

Al Cummings moved freely between the Seattle stations. In addition to KING, he did three tours at KOL and a stretch as the morning man at KVI. Seen here with a beard in this KOL publicity postcard, he declared, "Girls tell me that bearded men are warmer kissers. I always scent my beard with the aroma of mint—peppermint for the younger girls, and the US Mint for more mature dolls."

Jim French got his first radio job in Pasadena at age 14 and worked briefly in Honolulu before joining KING in 1952. He was KIRO's morning man from 1958 to 1971 and then did middays at KVI until 1978. In 1980, he rejoined KIRO and stayed until his retirement in 1994. In the last 25 years, he has produced over 700 radio dramatic shows, which are nationally syndicated under the name *Imagination Theater*. (Author's collection.)

Robert E. Lee Hardwick was KVI's morning man from 1959 to 1980. He was famous for publicity stunts like jet skiing from Ketchikan to Seattle, swimming from Seattle to Bremerton, and climbing Mount Kilimanjaro. Justus "Buddy" Webber, KVI's program director and afternoon host in the 1960s, was later seen on KOMO-TV. In 1962, Hardwick and Webber raced each other around the world to publicize the Seattle World's Fair. (Author's collection.)

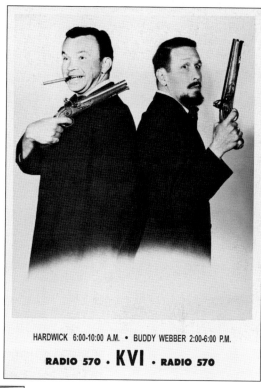

HARDWICK 6:00-10:00 A.M. • BUDDY WEBBER 2:00-6:00 P.M.

RADIO 570 • KVI • RADIO 570

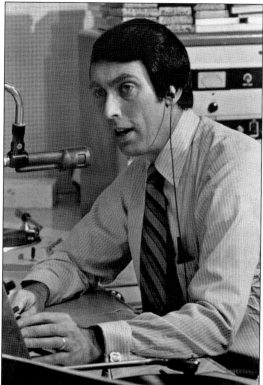

Larry Nelson started at Kemper Freeman's KFKF in Bellevue. KOMO hired him for evenings in 1966 and then quickly promoted him to host its morning *Breakfast Table* program. Larry had a genuine, cheerful voice that was a companion to millions of morning Puget Sound commuters. This photograph shows him in 1978 at mid-career. Nelson retired from KOMO in 1997 after 30 years as its morning man and died in 2007. (Courtesy of Gina Nelson.)

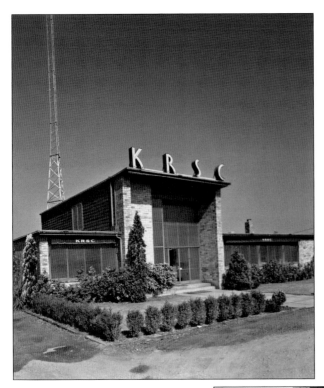

Palmer Leberman and Robert Priebe started KRSC in 1926 and ran it until 1949. It began in the Henry Building, later operating from the Spring Apartment Hotel and the Washington Athletic Club. They built this classic studio building at 2939 Fourth Avenue South in 1940. KRSC started Seattle's first FM and TV stations in 1948, which became KING FM and TV the next year. In 1953, Jessica Longston bought KRSC-AM and renamed it Country KAYO. (Courtesy of University of Washington Special Collections DM5777.)

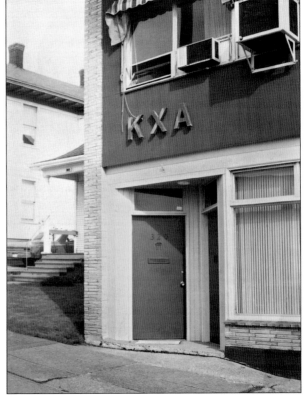

This modest building at 320 Second Avenue W was the home to KXA's studio and offices in 1970. An interesting detail in this snapshot is the KXA microphone flag fastened to the door. KXA, owned by California broadcaster Wesley Dumm, was Seattle's "Good Music" station, featuring a mixture of symphonic music, Broadway show tunes, and news. (Courtesy of Chris Dubuque.)

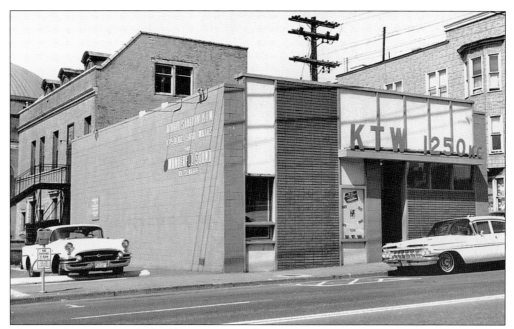

This was the KTW studio building at 710 Madison Street in the early 1960s. It was across the street from the First Presbyterian Church, which still owned the station. Manager and chief engineer James Ross was the son of the station's founder, John D. Ross. KTW broadcast adult music weekdays and religious programs on weekends, as pictured below. It shared its 1250 frequency with KWSU in Pullman and was off the air from sunset to 11:15 p.m. daily. In 1964, the church sold KTW along with a new FM license to David Segal, who tried Top 40 without success; he then sold it in 1966 to Norwood Patterson, but it soon went into receivership and reverted to the church. Fred Danz's Sterling Recreation Organization (SRO) bought KTW in the 1970s, and it became KYAC, while KTW-FM became KZOK. The AM station is now known as KKDZ, Radio Disney. (Above, courtesy of seatacmedia.com; below, author's collection.)

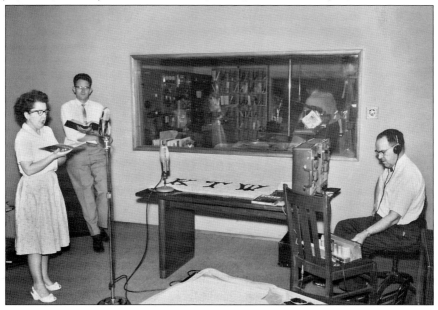

Lorenzo Milam was a volunteer at Berkeley's KPFA in 1958. He used inheritance money to buy an antiquated FM transmitter and spent the next three years looking for a broadcasting license anywhere the FCC would give him a frequency. That turned out to be 107.7 megahertz in Seattle, where he and engineer Jeremy Lansman put counter-culture station KRAB on the air from this former donut shop at Ninety-first Street and Roosevelt Way. The studio was a round table with a single microphone, and the antenna was on a telephone pole behind the building. The image below shows an eclectic but dedicated group of early KRAB volunteers. Milam went on to start 13 other stations around the country, becoming the "Johnny Appleseed of community radio." KRAB operated in nearly perpetual destitution until 1984, when it sold its valuable commercial frequency (now KNDD) and used the proceeds to build public station KSER in Lynwood. (Both, (author's collection.)

Eight

WALLY AND LESTER

The 1950s saw the rise of two self-made Northwest radio executives, Wally Nelskog and Lester Smith. Both men started with almost nothing and built successful Northwest radio station groups through their own hard work and business acumen.

Walter N. "Wally" Nelskog announced for several Seattle and Spokane stations before starting his popular *Wally's Music Makers* program on KRSC in 1950. In 1954, he built his first station, KUTI, in Yakima. Over the next five years, he built or owned KORD (Pasco), KQTY (Everett), KUDI (Great Falls), KQDY (Minot, North Dakota), KUDE (Oceanside, California), KYNG (Coos Bay), KYXY (San Diego), and KZZK (Tri Cities), as well as the Edmonds and Everett Cablevision systems. He also established and sold a music-syndication service. In 1959, he bought KLAN 910 in Renton and moved it to Seattle, changing the call sign to KIXI. It became Seattle's popular "Music You Remember" adult AM nostalgia music station in the 1970s and 1980s.

Lester Smith grew up in Brooklyn, attended New York University in 1936, and worked as an NBC pageboy. He served under General Patton during the war and was discharged in 1946 with the rank of major. He then worked as a radio advertising salesman for KYA in San Francisco and as the manager of KVSM San Mateo. In 1954, he and KVSM owner John Malloy bought KJR in Seattle for a reported $150,000. Smith soon sold KJR's antenna site to the Port of Seattle for $220,000, taking a 50-year lease back on the property for less than the taxes. They also bought KXL in Portland and KNEW (later KJRB) in Spokane.

Smith changed KJR to a Top 40 format, hiring popular disc jockeys such as Dick Stokke, Pat O'Day, Larry Lujack, Lan Roberts, and Lee Perkins. KJR shot up to number one and enjoyed almost a 40 percent local audience share for a decade.

In 1957, entertainers Frank Sinatra and Danny Kaye bought the three stations for $2 million, and Smith stayed on as manager. Sinatra sold out to Smith in 1964, and Kaye-Smith Enterprises was born. By the 1970s, Kaye-Smith owned 10 radio stations, a concert promotion company, recording studio, film production company, and a radio syndication company. Smith was one of six partners who brought the Mariners to Seattle in 1976.

Wally Nelskog showed an early interest in radio and held FCC amateur and first-class radiotelephone licenses by the time he graduated from high school in Everett. He was stationed in Anchorage with the Army Signal Corps during World War II. In 1946, while honeymooning with his wife, Anne, in New York, they secured a Muzak franchise for Spokane, which he operated until 1949. Radio work brought him back to Seattle, and he started his *Wally's Music Maker's* program on KRSC in 1950. It was soon the number-one program in its 2:00 p.m. to 6:00 p.m. time slot. According to Nelskog in a January 27, 1986, *Broadcasting* magazine article, in 1955 he moved himself, the show, and "all of the audience" to KJR, where he recorded a local audience 50 percent share—a Seattle record that has never been matched. (Both, courtesy of Carol Nelskog Arkell.)

WALLY NELSKOG

Now On

KJR

950 KC

every afternoon

2 to 6 P. M.

Monday thru Saturday

Music Maker's Maestro

KJR Seattle's NO. 1 INDEPENDENT RADIO STATION is proud to welcome Wally's Music Makers to its popular list of programs and personalities.

"Stay Where You Are On KJR"

In 1954, while doing his radio show and hosting teen dances on the side, Nelskog built this radio studio from scratch for $4,000 in his Arbor Heights garage. He bought a used transmitter and moved everything to Yakima in a rented truck, where he started KUTI. Two years later, he sold the station for $250,000. Now bitten by the entrepreneurial bug, he went on to buy and sell another 10 radio stations over three decades. (Courtesy of Carol Nelskog Arkell.)

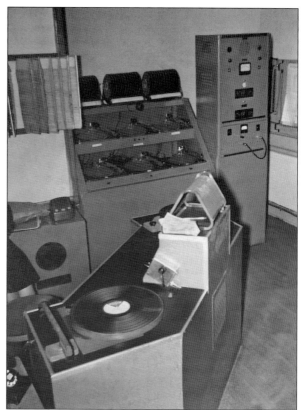

Nelskog put KQTY in Everett on the air in 1957 (1230 kilohertz, 250 watts). Here is the KQTY news car in front of the studios at 3021 Rockefeller Avenue. The car is a Renault Dauphine, introduced in 1956. *Time* magazine named it one of the 50 worst cars of all time, writing that if a person stood beside it, he or she could actually hear it rust. Nelskog sold KQTY in 1962, and it became KWYZ. (Courtesy of Carol Nelskog Arkell.)

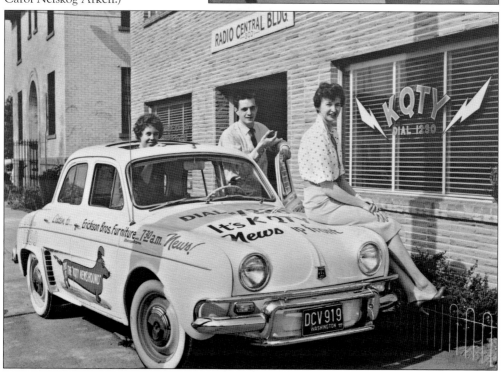

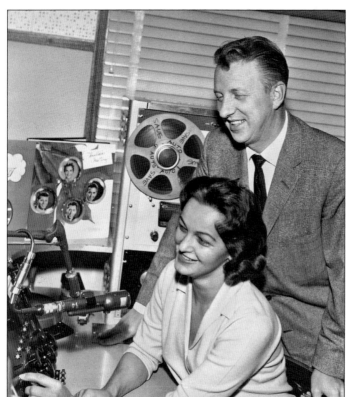

Wally Nelskog and his wife, Anne, look over the KQTY equipment that would broadcast Christmas music throughout downtown Everett in December 1960. Loudspeakers mounted atop the First National Bank and Medical Dental Buildings were set up to distribute Nelskog's music for the chamber of commerce. (Courtesy of Carol Nelskog Arkell.)

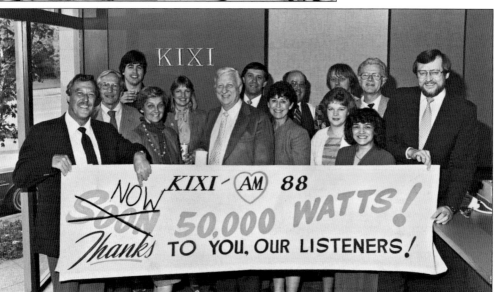

Nelskog's KIXI became Seattle's fourth 50-kilowatt AM station in April 1983. This required moving the station to Mercer Island and changing from 910 to 880 kilohertz. KIXI staff members seen here include station manager Jim Hawkins (holding the sign), Wally Nelskog (center), and general manager Dean Smith (far right). KIXI broadcast a popular mixture of adult standards and big-band music for 25 years from the 801 Pine Street building in downtown Seattle. (Courtesy of Carol Nelskog Arkell.)

Lester Smith partnered with entertainer Danny Kaye to form Kaye-Smith Enterprises. Together, they owned KJR in Seattle, KXL in Portland, and KJRB in Spokane. Smith turned KJR into Seattle's big Top 40 station, with air personalities like Pat O'Day, Larry Lujack, Lan Roberts, Emperor Smith, Dick Curtis, and many others. KJR held almost a 40 percent share of the local audience for a decade. (Photographs courtesy of Carol Nelskog Arkell and Alex and Bernice Smith.)

Both Smith and Kaye were aviation enthusiasts and amateur pilots, a common interest that helped cement their business relationship. Kaye learned to fly in 1959 and was a licensed multiengine pilot. Here are Smith and Kaye accepting delivery of a new Beechcraft Queen Air Model 65 for Kaye-Smith Enterprises at the Beechcraft factory in Kansas City around 1961. From left to right are Lester Smith, Beechcraft president Olive A. Beech, and Danny Kaye. (Courtesy of Alex and Bernice Smith.)

W7FDQ

WALLY NELSKOG

BOX 640

EDMONDS, WA

98020

USA

In 1986, Wally Nelskog sold KIXI AM/FM for $8 million and retired to cruise the Northwest on his boat. He enjoyed keeping in touch with his many friends on his ham radio station. Lester Smith and Danny Kaye sold KJR for $10 million, and Danny Kaye divested of his remaining interests in 1985. Les sold his last station, KXL, in 1999. Nelskog and Smith were market competitors but also good friends, and they died within months of each other: Wally died in February 2012 at age 92, and Lester passed away in October 2012 at 93. (Above, courtesy of Carol Nelskog Arkell; at left, Alex and Bernice Smith.)

Nine

Seattle's "Boss Jock" Radio

In 1954, Lester Smith became the new general manager of KJR. To save costs, he moved into modest studios next to the tower on the Duwamish Waterway. He adopted the new Top 40 concept, playing the most popular songs based on record sales statistics. With each passing year, more of the best-selling songs were rock-and-roll tunes, and soon KJR found itself attracting teenage audiences.

In 1957, Smith hired a young disk jockey named Pat O'Day (real name Paul Berg), who became a sensation among the local teenage audience. Within a short time, he was KJR's program director, leading a staff of popular deejays, including Larry Lujack, Lan Roberts, Emperor Smith, and Dick Curtis. KJR zoomed to an amazing 37 percent share of the Seattle audience and stayed on top for nearly a decade. Simultaneously, O'Day built a lucrative side business as a teen dance promoter. He became KJR's station manager in 1969, succeeded by Shannon Sweatte in 1974. Popular KJR air personalities in the 1970s included Charlie Brown, Gary Shannon, Norm Gregory, and Gary Lockwood.

Although KJR was beating all the big Seattle stations, its constant Top 40 challenger was KOL, located in another tiny building across the river on Harbor Island. On "Kolorful KOL, 13 Double O," one could hear Robert O. Smith, Dex Allen, Bill Bradbury, and Buzz Barr. Dick Curtis moved over from KJR to first become KOL's program director and moved up to station manager in 1969. He brought Lan Roberts from KJR to be his program director and morning man.

By the mid-1970s, Top 40 AM radio was past its prime, edged out by FM stereo rock stations that offered greater variety and album cuts. KOL fell away first. Beset by staff changes and internal turmoil, it was sold in 1976 and became the country music station KMPS. KJR hung on until the early 1980s, but Top 40's heyday was clearly over. KJR changed to classic hits, moved out of the Duwamish Waterway studios in 1988, and then adopted a sports-talk format in 1992. KOL's Harbor Island studios and tower were demolished in 1981, followed by the KJR building and tower in 2000. Now, even the physical remnants of Seattle Top 40 radio are gone forever.

KJR and KOL, Seattle's Top 40 competitors, broadcast from opposite sides of the Duwamish Waterway. In 1952, KOL moved out of the Northern Life Building and into this transmitter building on Harbor Island. The industrial area had grown, and the once-isolated location was now surrounded by gasoline storage tanks, railroad tracks, and shipyards. In 1965, the station spoofed KING's broadcasts from the Space Needle by promoting KOL's *Music from the Mudflats*. (Courtesy of Dick Curtis.)

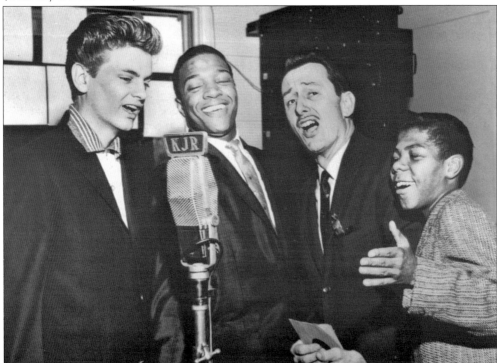

Dick Stokke, a popular KJR disk jockey in the 1950s, was known for his ad-libbed, irreverent comments. Here, he belts out a tune with rock-and-roll celebrities Phil Everly (Left), Clyde McPhatter (second from left), and Frankie Lymon (far right). In the 1960s, Stokke was heard on KFKF, KIXI, and KOL. His on-air partner, Merrill Mael, said of him, "Dick was the best ad-libber in Seattle radio." Stokke died in 1987. (Author's collection.)

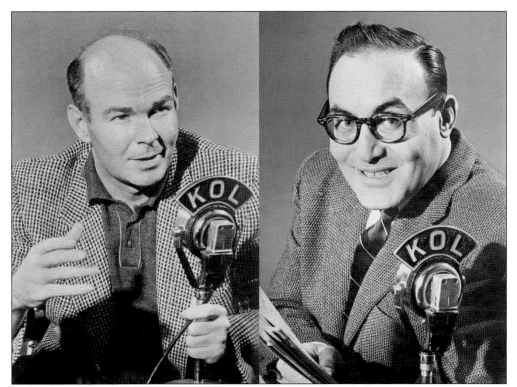

Here are four KOL voices heard from the late 1950s. Ray Hutchinson (above, left) did the morning show in 1959. In the 1960s, he moved to KCBS in San Francisco, where he reported business news from the Pacific Stock Exchange for many years. Portland's Ric Thomas (above, right) was on KOL for four years and then moved back to KEX in Portland. Bob Waldron (below, left), who joined KOL from classical KISW (FM), was known for his hatred of rock and roll, saying it "sounds like a drunk with the heaves." Johnny Forrest (below, right) came to Seattle in 1936 and worked for over three decades at KOL, KIRO, and KFKF as a news broadcaster, anchorman, and sportscaster. He joined KOL as program director in 1949 and did his own show in the 1950s, remaining as a newscaster throughout the 1960s. (Both, courtesy of Bill Taylor and Maia Santella.)

Dick Curtis was one of KJR'S popular disk jockeys from 1960 to 1967. After graduating from Lincoln High School in Tacoma, Curtis served as a radio operator in the Air Force during the Korean War and took his first radio job at KBRO in Bremerton before coming to KJR, where he worked alongside Pat O'Day, Lan Roberts, Larry Lujack, Tom Murphy, and other radio stars. In 1967, he was named program manager of KOL and later became its general manager. He was successful in creating Seattle's first commercial FM rock station KOL-FM, now KMPS. Pictured above from left to right are Lee Perkins, Pat O'Day, Curtis, and Jerry Kaye in the KJR production room around 1962. Below, Curtis chats with a group of young KOL contest winners at the Windjammer Restaurant (now closed) in Ballard's Shilshole area of Seattle in November 1967. (Both, courtesy of Dick Curtis.)

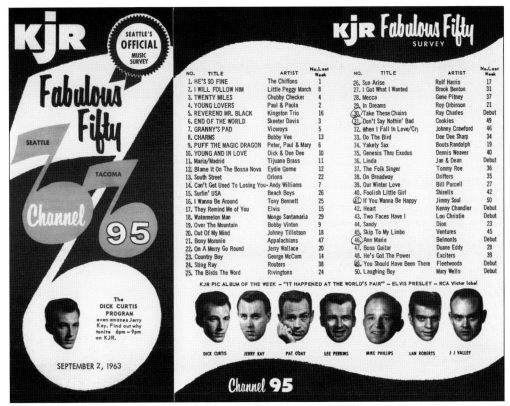

Weekly music surveys were an essential part of Top 40 radio in the 1960s and early 1970s and were an important station promotion vehicle. Most hit music stations published weekly lists of the most popular songs based on local record sales, jukebox plays, and the *Billboard* magazine Hot 100 singles charts. They were usually distributed at the record stores that sold the latest hit 45s, and the stores in turn reported their sales statistics to the stations. Today, these surveys have developed a following as collectibles among baby boomers. Seen above is a KJR music survey from 1963 showing the complete KJR air staff. Below is a KOL "Solid Sixty" survey from 1961. (Both, author's collection.)

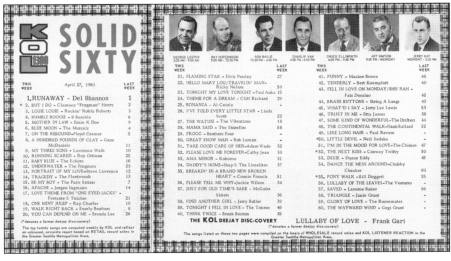

In 1963, Archie Taft Jr. sold KOL AM/FM to Mark Goodson and Bill Todman for $900,000. The two men were the producers of some of the biggest 1960s TV game shows. The new owners felt the station had not been successful enough competing with KJR, and so they abandoned Top 40 in favor of an MOR format. But, after two years of low ratings, management relented, and Top 40 returned. "KOLorful KOL Thirteen Double-Oh" was born in the spring of 1965. To kick off the new format, four new KOL disk jockeys toured every high school in the area, giving away about 10,000 free records. They traveled in the KOL "Woodie Wagon," complete with surfboard. Listeners were asked to collect as many signatures as possible; the longest list won the wagon, surfboard, and a family weekend at the ocean. Here is the KOL contest vehicle with deejays, from left to right, Tommy Vance, Don January, Rhett Hamilton Walker, and Danny Holiday. (Courtesy of Dwight Small.)

Dick Curtis | Lan Roberts | Tom Connors

Robin Mitchell | Dave McCormick | Dex Allen

Bill Taylor | Don Hughes, News Director | Logan Stewart

In 1967, Buckley Broadcasting bought KOL AM/FM for $1 million. Buckley named program director Dick Curtis as its station manager in 1969, and he lured Lan Roberts away from KJR to take his old position of program director; however, Robin Mitchell became the program director the next year, and Roberts soon went back to KJR. Shown here are some of the many voices heard on KOL during the late 1960s and early 1970s: Dick Curtis, Lan Roberts, Tom Connors (later with KTAC and KRKO), Robin Mitchell (later at KYYX), Dave McCormick, Dex Allen, Bill Taylor (later a KVI newsman), Don Hughes, and Logan Stewart. Others not shown included Burl Barer, Buzz Barr, Jeff Boeing, B.R. Bradbury, Don Burns, Greg Connors, Danny Holiday, Lee Perkins, Ray Ramsey, Bobby Simon, Robert O. Smith, J.J. Valley, Rhett Hamilton Walker, and Don January. (Courtesy of Dwight Small.)

On April 1, 1970, as an April Fool's joke, Top 40 KOL and Country KAYO swapped their drive-time disc jockeys for a day. Here are Lan Roberts (wearing the hat) and Robert O. Smith in the KAYO control room playing country music hits; meanwhile, over at KOL, Bobby Wooten and Buck Ritchey were trying to make sense out of rock and roll. (Courtesy of seatacmedia.com.)

Lan Roberts was KJR's most creative air personality during its Top 40 era. Pat O'Day said of him, "He had a childlike imagination that was a thing of beauty. He wanted radio to go beyond the mundane. He wanted to make people laugh every hour." Coming to Seattle from New Orleans, he was heard on KJR from 1962 to 1968 and then at KOL for two years before returning to KJR from 1970 to 1973. (Author's collection.)

Ten

RADIO AROUND THE SOUND

Although Seattle was the natural radio center of the Puget Sound region, Tacoma, Everett, and Olympia each had their own thriving broadcast stations.

The Love Electric Company started Tacoma's KMO in 1922. Then, Carl Haymond bought the station in 1926 and ran it for 30 years, first from studios in the Winthrop Hotel, then from the Keyes Building, and later from its transmitter site on Pacific Highway East in Fife. As the city's principal radio voice, KMO featured popular announcers, local sports, and topics of local interest. Hammond later started KMO-TV channel 13, but he then put the stations up for sale after he lost the NBC network affiliation to KOMO-TV. In later years, KMO was owned by Elroy McCaw, J. Archie Morton, Ed Wheeler, and Jim Baine. It is now known as KKMO.

Tacoma's other broadcasters were KVI and KTBI. KVI was established in 1927 as a 50-watt, limited-hours station. Edward Doernbecher acquired it that year and moved the station into the Hotel Tacoma. Under the Doernbecher family, KVI grew in stature over the years, gaining full-time operation, network affiliation, higher power, and better coverage. It gradually increased its presence in Seattle until officially changing its city of license to Seattle in 1949.

Cecil Cavanaugh, a lumber company executive, put KTBI on the air on 1490 kilohertz in 1941. The station saw many changes in ownership, frequency, and operating hours until settling on 850 kilohertz with full-time operation. It was known as KTAC when Jerry Geehan bought it in 1952.

The Leese Brothers started KFBL in Everett in 1922. They manufactured car batteries, and so they ran their five-watt transmitter on storage batteries from the back of their shop. They eventually increased power and rented legitimate studio space. Lee Mudgett leased the station in 1934, changing it to KRKO, and then in 1937 he bought the station with partners Bill and Archie Taft Jr., the sons of the owner of KOL. Mudgett's wife, Pat, became a popular KRKO personality in the 1940s.

The Taft family also had an interest in KGY in Olympia, one of Washington's oldest stations, which they had purchased from St. Martin's College. In 1939, they sold it to an Olympia journalist named Tom Olsen, who focused the station on local needs and issues. Olsen moved KGY into the Rockway-Leland Building in 1941, and in 1960 he relocated it to a mid-century modern studio built on pilings over Budd Inlet, where it remains today. The Olsen family still owns KGY, and it is now managed by his great-grandson Nick Kerry.

Edward Morris Doernbecher (1882–1937) was the son of a wealthy Portland manufacturer whose endowment created the Doernbecher Children's Hospital in Portland. In 1927, Edward acquired KVI, a new Tacoma startup 50-watt station, operating on 1280 kilohertz with limited hours. He moved it into the Hotel Tacoma at the corner of Ninth and A Streets (seen here in a turn-of-the-century view). KVI operated here until 1933, when it moved to the Rust Building. (Author's collection.)

Actor Ronald Reagan visited KVI on October 18, 1940, for the world premiere of his film *Tugboat Annie Sails Again*. Pictured in the KVI studios in the Rust Building are, from left to right, Alan Hale Sr., Reagan, columnist Hedda Hopper, Mayor Harry P. Cain, Marjorie Rambeau, and Donald Crisp. The movie premiered simultaneously at three downtown Tacoma theaters: the Roxy, the Music Box, and the Blue Mouse. (Courtesy of Tacoma Public Library, D10341-13.)

On November 24, 1939, Santa Claus arrived by plane direct from the North Pole at Mueller-Harkins Airport. Here, he shakes hands with Bernard "Bud" Oswald before addressing Tacoma's children over KVI. Santa then boarded a new Packard automobile for visits to the Peoples Store and other Tacoma locations. (Courtesy of Tacoma Public Library, D9112-16A.)

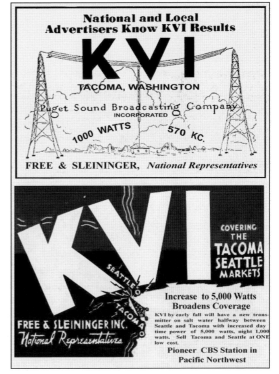

The top ad from *Broadcasting Magazine* in 1935 shows a graphic representation of KVI's 1,000-watt antenna near Kent. The lower ad, one year later, publicizes the new tower that engineer Jim Wallace built at "KVI Beach" on Vashon Island. It effectively doubled KVI's coverage and gave the station local signal quality in Seattle for the first time. KVI then opened auxiliary studios in the Olympic Hotel in downtown Seattle. (Author's collection.)

Here is the Knapp Business Orchestra broadcasting from the KMO studios in the Winthrop Hotel in 1927. The ensemble consisted of students from Knapp Business College, the first institution in Pierce County to be organized exclusively for business education. Established in 1921, the college placed its emphasis on the accounting and secretarial fields. (Courtesy of Tacoma Public Library, Boland-B16853.)

KMO started in 1921 as a 10-watt station. Carl Haymond bought it in 1926 and raised the power to 250 watts. The studios were in the Winthrop Hotel, with the transmitter at Rhodes Department Store. In 1931, Haymond erected these towers at the Carstens Packing Company Building, now with 500 watts. KMO's studios later moved to the Keyes Building, and a new 1,000-watt tower went up on Pacific Highway South in Fife. (Courtesy of Tacoma Public Library, Boland-B24896.)

KMO'S popular daytime announcer Arnold Benum is shown at the controls in the KMO control room in the Keyes Building in 1946. There are three 16-inch transcription turntables to his right, with the center one capable of recording disks. The patch panels were used to insert local programs into the regional Mutual network line. The chimes on the top of the console were played on the daily *Toast to Bread* program. (Courtesy of the Museum of History and Industry.)

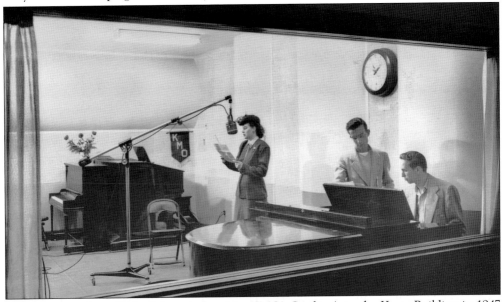

This is a view through the foyer window into KMO's Studio A in the Keyes Building in 1947 while a program rehearsal is in progress. KMO's programs featured easy-listening music, local news and sports, and Mutual-Don Lee Network programs. The Tacoma United Press news bureau was located at KMO, and its staff presented eight newscasts each day. (Courtesy of Tacoma Public Library, D29762-3.)

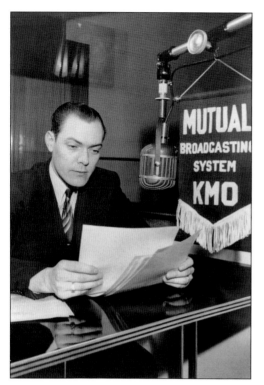

In the photograph at left, KMO chief announcer Verne Sawyer reads announcements over the air from the KMO studios in the Keyes Building on Ninth Street and Broadway in Tacoma on March 25, 1944. Below, sportscaster Rod Belcher begins his career at KMO in 1946. Like his Seattle counterpart Leo Lassen, Belcher became a master at the art of sports re-creations, doing play-by-play broadcasts from a studio working only with bare statistics received by Teletype. Many stations did them because they lacked the financial capacity to send announcers to live events. Belcher did game re-creations for four years at KMO, and he did his first live, play-by-play game of a University of Washington Huskies game in 1949. In 1951, Belcher became the sports director for KOL in Seattle and then did play-by-play broadcasts for the Seattle Rainiers in 1957 and 1958. In 1960, he became the sports director for KING radio and television, where he was seen and heard for nine years. (Both, courtesy of Tacoma Public Library: at left, D12758-2; below, D24596-2.)

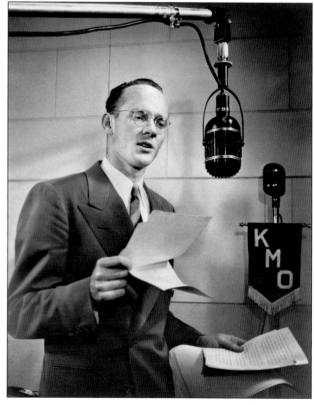

In 1941, KMO broadcast the 10th Annual Tacoma Winter Carnival at Paradise, Mount Rainier National Park. Pictured from left to right are Dee Whitman of Stadium High School, Dick Ross, Mayor Harry P. Cain, Virginia Davis, KMO manager Jerry Geehan, and Anele Larson of Lincoln High School. Winthrop Motor provided the DeSoto automobiles that were used to transport dignitaries. (Courtesy of Tacoma Public Library, D10762-36.)

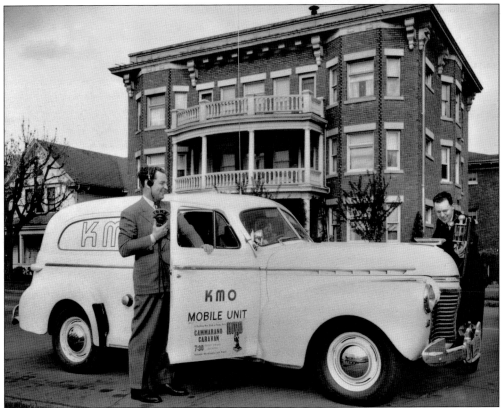

Here is the KMO mobile unit in 1947, with Verne Sawyer and chief engineer Max Bice. The small glass jar on the front of the vehicle contained gasoline. During KMO's weekly *Cammarano Caravan* program, the driver would connect the gas line to the glass jar, and when the vehicle ran out of gas, he would go up to the nearest house, broadcasting live. If the residents had any Cammarano beverages, they won prizes. (Courtesy of Tacoma Public Library, D27290-2.)

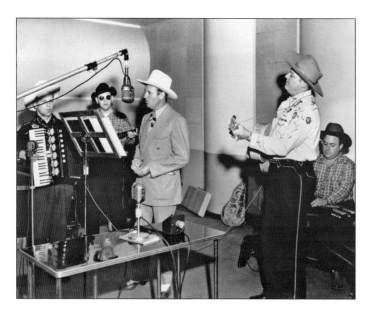

Cowboy songs were extremely popular across the country in the 1930s and 1940s. Their popularity was driven by the idealized depictions of the cowboy in motion picture westerns, and many radio stations of the era featured at least one live western band. This is a publicity postcard sent out to listeners in the 1930s by the Three Crediteers and the Lone Star Wranglers, heard on both Tacoma radio stations, KVI and KMO. (Author's collection.)

Western singer and movie star Gene Autry was in Tacoma on July 15, 1949, for a performance at the College of Puget Sound Fieldhouse. He also performed as a guest on KMO's *Cherokee Jack* program in Studio A at the Keyes Building. Bandleader Cherokee Jack Henley and his Rhythm Riding Wranglers had their own show on KMO. He is playing guitar to the right of Autry, with Shorty Justis behind him. (Courtesy of Tacoma Public Library, D43736-13.)

Pianist Wendall Kinney broadcast the daily program *Patterns in Black and White* on KMO for many years. He combined his piano talents with informal chatter, writing, and delivering his own commercials. His sincerity brought such good results that advertisers clamored to be on his program. He repeated his program's success in Bakersfield in later years. Here is Kinney beginning his radio career at KXLE in his native Ellensburg. (Author's collection.)

KMO broadcast a speech by Pres. Harry S. Truman from a platform on the corner of South Ninth Street and Broadway in Tacoma on June 10, 1948. Truman blasted the Republican-controlled "do-nothing" Congress for its inaction on inflation and price controls. He also attacked their tax-reduction plan as a "rich man's tax law—for the relief of the rich." He spoke to large crowds in Seattle and Bremerton on the same day. (Tacoma Public Library, D33820-9.)

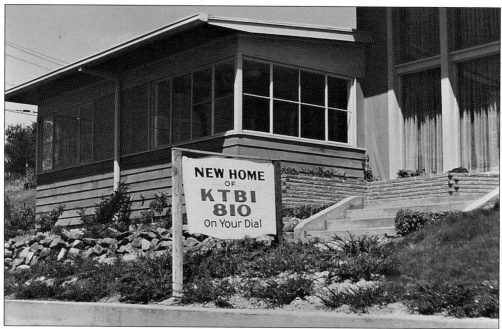

Former KIRO manager Tubby Quilliam bought KTBI in 1945 and erected this modern building at 2715 Center Street (above and below). Quilliam moved KTBI from 1490 kilohertz full-time to 810 kilohertz daytime hours only, trading reduced hours for a better frequency with higher power and improved coverage. The new building was designed for expansion into television, but the Tacoma TV assignment went instead to the Tacoma News-Tribune (KTNT-TV). Operating at a loss, Quilliam sold the building and moved KTBI to the Winthrop Hotel. On February 11, 1952, the station moved to 850 kilohertz full-time with a directional nighttime antenna and became KTAC. Quilliam sold KTBI in 1952 to KMO manager Jerry Geehan and local investors. They in turn sold it to Ron Murphy, who increased power to 10,000 watts. The station is now known as KHHO. (Above, courtesy of Tom Read, Northwest Pioneer Broadcasters; below, Tacoma Public Library, D29613-15.)

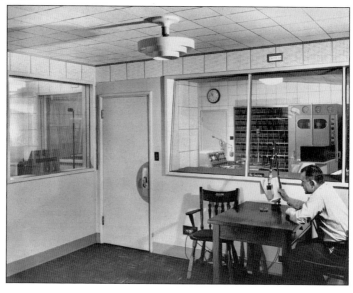

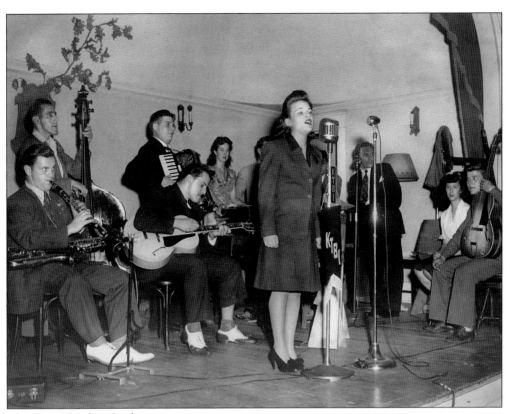

The *Grassi Brothers Jamboree* was broadcast live over Tacoma's KTBI from the USO at Thirteenth Street and Pacific Avenue every Tuesday evening at 8:30 p.m., sponsored by Grassi Brothers auto dealers. The unknown singer in this 1943 broadcast is possibly Mickey McDougall. KTBI went on the air on August 31, 1941, with studios on the second floor of the Puget Sound Bank Building at 1117-9 Pacific Avenue. (Courtesy of Tacoma Public Library, D16042-7.)

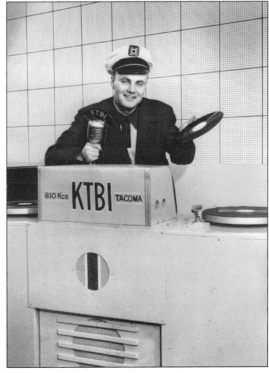

Here is KTBI disk jockey Steve Sorenson in November 1951, wearing his familiar cap. This was KTBI's portable studio, used for remote broadcasts from the Puyallup Fair and other locations. Sorenson later operated a radio and TV parts store in Spokane but kept his hand in broadcasting. In 1956, he hosted a marathon DJ program lasting 85 hours, five minutes, and 20 seconds from his Spokane store's display window. (Courtesy of Tacoma Public Library, D62413-7.)

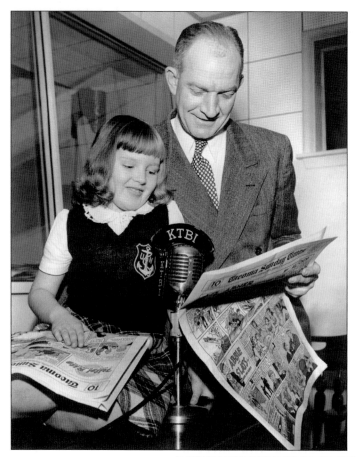

Here are Uncle Van and Sharon reading the Sunday funnies on KTBI in December 1948. Reading the comics on the air was a children's feature offered by many radio broadcasters in the days before television. The tradition began in 1945 when New York mayor Fiorello LaGuardia read the comics over WNYC during a citywide newspaper strike. It became one of his best-remembered actions as mayor, and many stations soon imitated it. (Courtesy of Tacoma Public Library, D37082-2.)

KTBI announcer Preston Price interviews Washington author Margaret McKenney and Alta Grim of the Washington State Library about 1950. For the first time, radio stations were using tape recorders to record programs for later broadcast. These early devices offered much greater convenience than the traditional acetate disc recorders, which were heavy, expensive, and cumbersome to operate. The recorder being used here is a Webster Electric Elektrotape, introduced in 1950. (Susan Parrish photograph collection, courtesy of Washington State Archives.)

Tacoma native Thomas Wilmot Read had a permit to build KTWR-FM in 1958 before his 21st birthday. He bought a used transmitter and financed the studio equipment from Gates Radio Co. The tower was on the Peck Building at Sixth Street and Grant Avenue. Read joined with Clay Huntington's KLAY 106.1, and both stations used the same air staff and antenna. He sold KTWR to Jerry Geehan's KTAC in 1964, and it is now KMTT. (Courtesy of Tom Read, Northwest Pioneer Broadcasters.)

Fr. Sebastian Ruth was an early wireless experimenter. This was his original wireless shack at St. Martin's College in Lacey where 7YS started as a spark station transmitting Morse code; however, it began transmitting music concerts with a 10-watt transmitter as KGY in March 1922. The studio was soon moved to a log cabin on the campus, and the station called itself "the log cabin station where the cedars meet the sea." (Courtesy of Nick Kerry.)

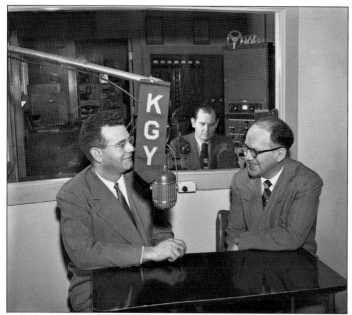

KOL's Archie Taft bought KGY in 1932. He moved the station to Olympia and increased power from 10 to 100 watts. Then, journalist Tom Olsen (right) bought the station in 1939. Before becoming a broadcaster, the Olympia native had been a sports reporter for the *Seattle Star* and a motion picture theater manager. Here, he interviews D. Downing, representing Secretary of State Dick Watson, in the 1950s. (Susan Parrish photograph collection, courtesy of Washington State Archives.)

A KGY Announcer conducts a live, man-on-the-street interview program in Downtown Olympia in the 1940s. This popular radio format involved stopping pedestrians in a public place and asking for their answers to important questions of the day. These were spontaneous interviews during a chance encounter; unrehearsed discussions with people selected completely at random. The results were sometimes unpredictable, eventually leading to the demise of the concept. (Courtesy of Nick Kerry.)

In 1941, KGY moved its studios to the newly completed Rockway-Leland Building at the corner of State Avenue and Washington Street in the heart of downtown Olympia. The broadcast tower was prominently placed on the roof of the building. Coincidently, the building is now the home of Olympia's KXXO-FM Mixx 96.1. (Courtesy of Nick Kerry.)

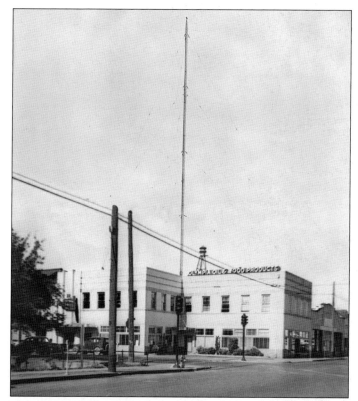

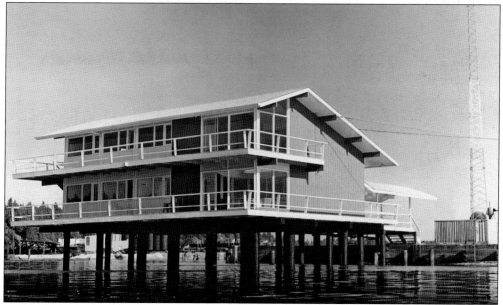

After outgrowing its space in the Rockway-Leland Building, KGY hired architect Robert Wohleb to design a studio at the top of the Port of Olympia Peninsula. Built in 1960 on pilings directly over the water, it is one of the most uniquely situated stations in the country. KGY continues to broadcast from this building today and is still owned by the Olsen-Kerry family. (Courtesy of Nick Kerry.)

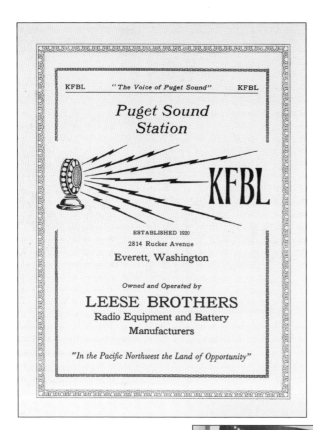

Here is a 1926 advertisement for Everett's KFBL, "The Voice of the Puget Sound." It was operated by brothers Otto and Robert Leese from their auto repair shop at 2814 Rucker Avenue. They built automobile storage batteries, so they chose to operate their tiny five-watt transmitter entirely from batteries. They bragged that the station used enough battery power to run an electric chair. KFBL was first licensed on August 25, 1922. (Courtesy of Andrew Scotdal and the Everett Public Library.)

KFBL's manager and engineer Lee Mudgett leased the station from the Leese Brothers in 1934 and changed the call sign to KRKO. In 1937, he joined with Archie Taft Jr. to purchase the station outright. During the war years, Mudgett's wife, Pat, hosted a special daily *Women in Wartime* program. Its goal was to "classify and clarify for women listeners war time facts regarding diet, health, foods, clothing and housing." (Courtesy of Andrew Scotdal.)

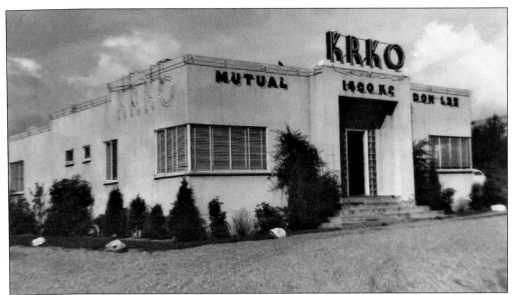

In 1945, Bill Taft and Archie Taft Jr., the sons of Seattle radio pioneer Archie Taft Sr. (KOL), purchased controlling interest in KRKO from Lee Mudgett. Bill then bought out his brother's shares in the 1950s. In 1957, he purchased a rural site along the Lowell-Larimer Road in southeast Everett, where he built an all-new facility for KRKO. Eight acres of farmland were cleared, and a new studio building with two 225-foot steel towers was constructed, as seen above. Thelma Taft designed the state-of-the-art studios, which included four turntables and a top-of-the-line RCA console. The new transmitter was a Gates model BC-5P, the best of its day. Below, Earl Gerdon is on the air in the KRKO control room. (Both, courtesy of Andrew Scotdal.)

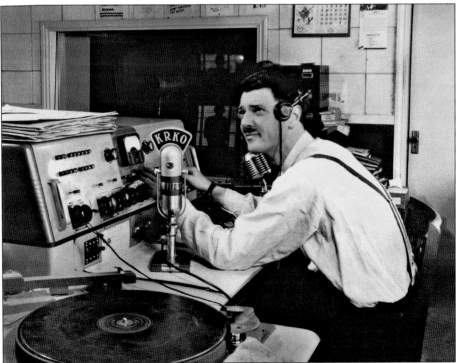

Discover Thousands of Local History Books
Featuring Millions of Vintage Images

Arcadia Publishing, the leading local history publisher in the United States, is committed to making history accessible and meaningful through publishing books that celebrate and preserve the heritage of America's people and places.

Find more books like this at
www.arcadiapublishing.com

Search for your hometown history, your old stomping grounds, and even your favorite sports team.